Published by 535
An imprint of Blink Publishing
3.08, The Plaza,
535 Kings Road,
Chelsea Harbour,
London, SW10 0SZ

www.blinkpublishing.co.uk

facebook.com/blinkpublishing
twitter.com/blinkpublishing

Hardback – 978-1-9116-0053-4
Ebook – 978-1-9116-0093-0

A CIP catalogue of this book is available from the British Library.

Designed by Envy Design
Printed and bound by UAB Balto Print

5 7 9 10 8 6

Blink Publishing is an imprint of the Bonnier Publishing Group
www.bonnierpublishing.co.uk

COMEDY WILDLIFE PHOTOGRAPHY AWARDS

EDITED BY PAUL JOYNSON-HICKS
AND TOM SULLAM

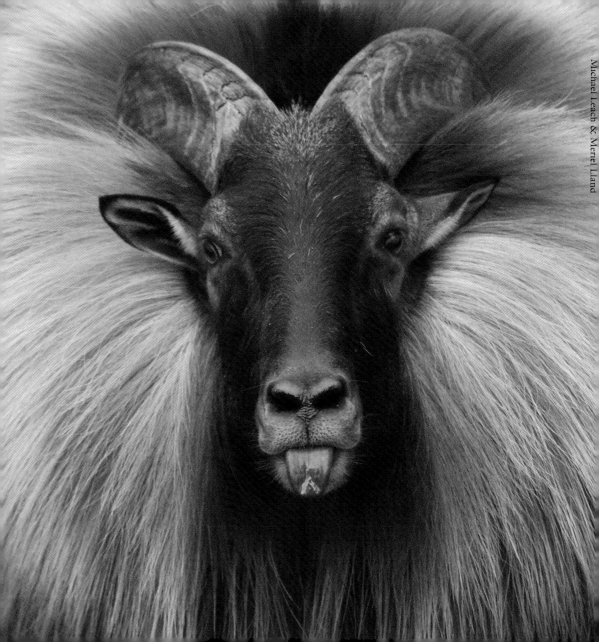

FOREWORD

BY HUGH DENNIS

First can I say how delighted I was to be asked to write the Foreword to this magnificent book of photographs, even though I know in my heart of hearts that no-one will ever read the words I have written. However carefully crafted the Foreword is, it is always the section that gets by-passed on the way to the heart of the book – in this case some exquisite images of animals being hilariously funny. Why look at pages 1 and 2 when the photos start on page 3? Expecting anyone to pay attention to a Foreword is a complete misunderstanding of human nature. What fool doesn't click on the on-screen button saying 'You can skip this ad in 3, 2, 1 seconds'? Who has ever read the instruction book for their washing machine? No-one. So, if you have discovered this bit, whether it be while browsing in a bookshop, or perhaps having dropped this much-loved volume to find it has fallen open at this page, I thank you. I know that if these words had been separate and in a polythene wrapper they would be lying unopened in a kitchen drawer next to the manual for a microwave you threw away 5 years ago.

So why did I become a judge of these somewhat unusual awards? Well first it's because I was cornered by Paul Joynson-Hicks on a small airstrip in the Serengeti and asked if I would take part, and secondly because they plug an important gap. We all know how inspiring the physical and animal world has been to writers, poets, filmmakers and musicians. Without it we would never have had the magnificence of Mendelssohn's 'Fingal's Cave', Beethoven's 'Pastoral Symphony', the lyrical beauty of Wordsworth's most famous poems, or the straight-to-video nonsense of my least liked film of the 1980s, *Under the Volcano*. Without filmmakers realising the intense human connection with animals, we would never have had *The Jungle Book*, *The Lion King* or *Madagascar*, and yet there is an aspect of the natural world that seems sorely neglected, namely how funny animals can be in the wild. Animals, inadvertently, can be hilarious. Just skip this Foreword like you really want to, get on to the real meat of this book, and you will see what I mean.

Secretly of course, and say it quietly, it sometimes isn't just the animals that are funny but also the people watching them. About five years ago I took my family to the Mara River to watch the crossing of the wildebeest. About half an hour in I realised that in the jeep next to ours, avidly watching one of the greatest spectacles nature has to offer, was Andre Agassi. So, I decided to chat to him across the vehicles. I asked him about the crossing, the crocodiles and the blind faith of the migrating animals, but I never dared ask him the question I really wanted to, namely why, in the middle of the magnificent African landscape, he seemed to be wearing full tennis kit?

OK you can look at the rest of the book now. Enjoy!

Hugh Dennis

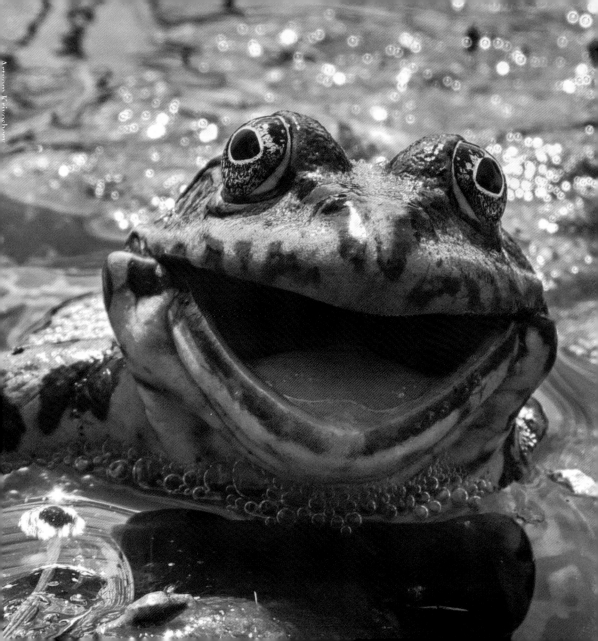

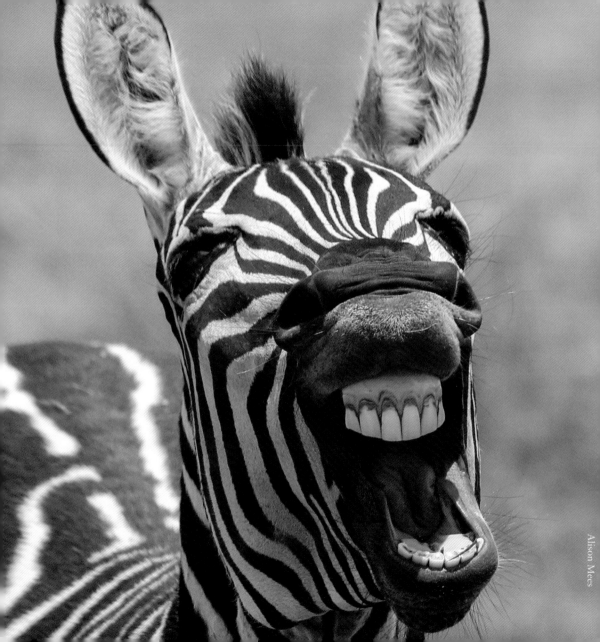

INTRODUCTION

HOW DID IT ALL BEGIN? OUR KIDS OFTEN ASK.

Allow us to take you back two and a half years to Usa River, just outside Arusha in northern Tanzania, only hours away from the Serengeti, one of the world's most spectacular ecosystems. This is where Paul Joynson-Hicks lives with his family. As a seasoned wildlife photographer, he is passionate about these wild areas, observing the importance of these fantastic creatures being around for his children and their children in turn to witness. That is a big part of why he created the Comedy Wildlife Photography Awards. Well, that and the fact that he loves funny animal pictures!

It was a dark and stormy night ... or more likely a steaming hot African day when, after entering yet another futile photography competition, Paul realised that there was no award that celebrated funny animal pictures. Through a profound love for the wild and the huge disappointment at never being recognised for his funny animal pictures, the Comedy Wildlife Photography Awards were born.

Paul built a website, solicited the help of a few wonderful judges, found some amazing sponsors and, bang, off it went. He received superbly funny submissions from far and wide: from the USA to the UK, India to South Korea, and even as far as Australia and New Zealand. Newspapers and media outlets wrote about the award.

The next year, in 2016, in his infinite wisdom, Paul invited Tom Sullam on board, a friend and a fellow photographer, who was already a judge. Unfortunately for Paul, Tom had managed to win a couple of photo competitions already, something of a sticking point between them. Indeed, this was certainly no marriage made in heaven. One was funny; the other one didn't think so. One was talented; the other one didn't think so. But what these two did share was a love for the environment, wildlife, and the general well-being of the planet.

That year, Paul and Tom drew more submissions, and more attention. Since we launched the competition two years ago we have received a whopping 3,500 terrific entries, making the judging stages of the competition extremely difficult. We have included those winners along with some of our favourite photographs in these pages.

This book hopes to raise awareness about the animals and areas of the world that are in serious danger. For example, if we carry on at the rate that we are going, there is a very high chance that rhinos and elephants will no longer walk this earth in 50 years. To observe such majestic beasts and to know that, unless we drastically change our habits, they will completely disappear, is utterly heartbreaking. Sadly, it is not just these massive creatures, but many, many more species that are in danger.

We have partnered with the Born Free Foundation, an international wildlife conservation organisation, to help us spread that message. They work tirelessly to protect wildlife around the globe. Their mission is to keep wildlife in the wild, and they hope to put an end to entrapment and return captive animals to their natural habitat.

We give 10 per cent of all the revenue we receive as the Comedy Wildlife Photography Awards straight to them. That's right: by buying this book, you have already embarked upon your wonderfully enlightened journey to becoming a conservationist.

There's more you can do, too. Again, that's where the Born Free Foundation comes in. They can help you decide how to help. You may be able to volunteer in your local area to help conserve woodlands or perhaps pick up litter. Or, if time is limited, you could donate to the Born Free Foundation and become part of their family, just as we did. We've included resources for how to help in the back of this book.

We hope these funny animal pictures make you laugh. They made us laugh, and they made us admire the beauty and diversity that is on offer to us in the world today. But we also hope the images inspire you to join us in our efforts to protect these funny – and vulnerable – animals.

Thank you.
Paul and Tom
www.comedywildlifephoto.com

THE WHITE RHINO is a rare creature, with only around 20,000 of them left in the wild. Rarer still is the two-headed White Rhino, shown here.

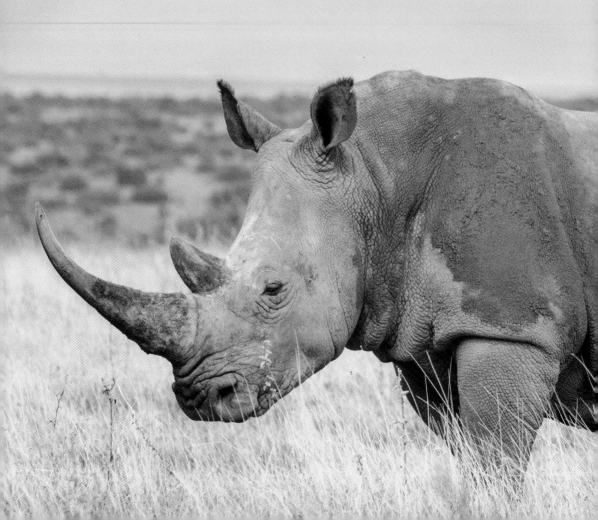

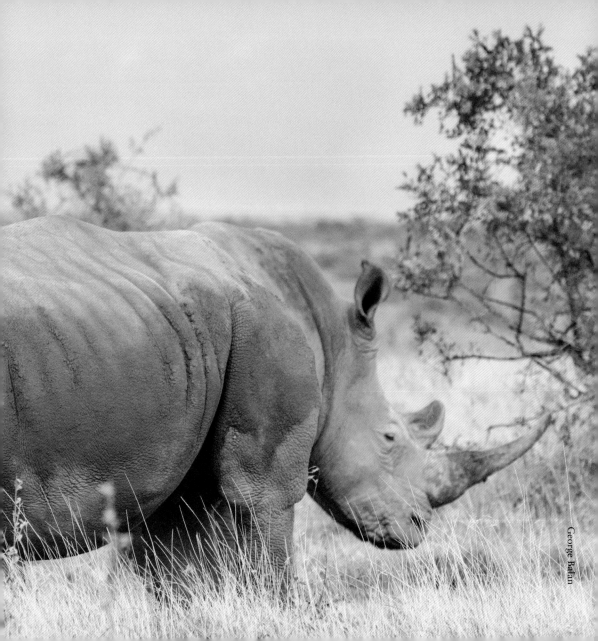

George Balan

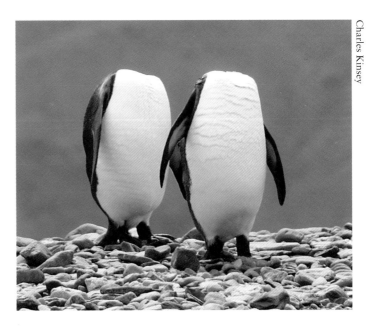

THEIR REMARKABLE double-jointed necks mean that when King Penguins preen themselves, they look like they have suffered an accident at the hands of a low-flying helicopter.

NAMED FOR their large curved horns, which can weigh up to 14 kilogrammes (30 lbs) each, Bighorn Sheep live in large herds. And it looks like they enjoy a good gossip.

GREAT EGRET populations have recovered since they were persecuted in the late 19th century for their feathers. A pair made history by breeding in the UK for the first time in 2012. Fingers (and necks) crossed they will continue to thrive.

Robert Ross

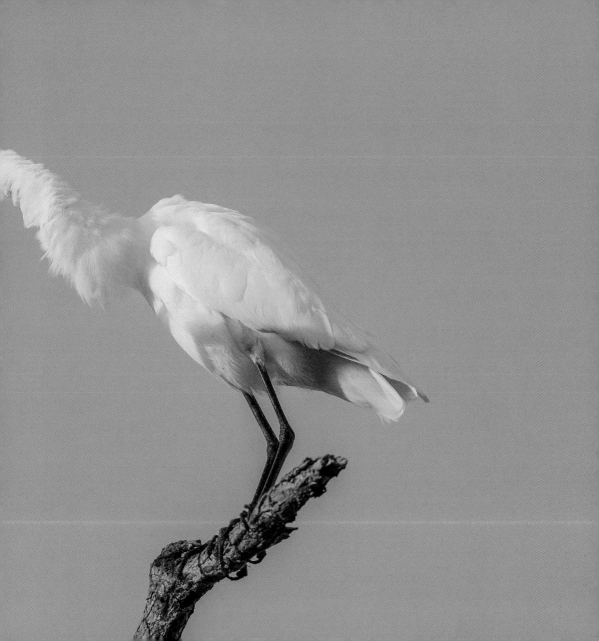

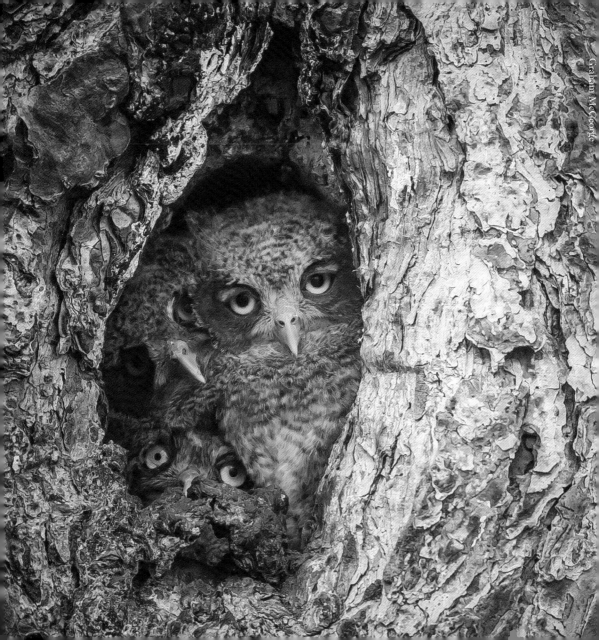

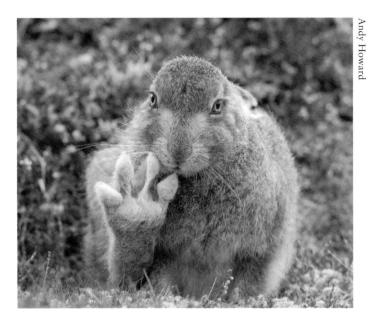

Andy Howard

THIS SUPER furry animal is a Mountain Hare which can reach speeds of up to 60 km/h (37 mph). It's no wonder it needs to stretch afterwards.

EASTERN SCREECH OWLS often nest in tree trunks in gardens and yards in North America, but the tree cavities can be a bit of a squeeze after a few weeks!

THIS ALPINE IBEX, a type of mountain goat, is especially social with members of the same sex. This one looks like he might have had a heavy night on the slopes.

Yuzuru Masuda

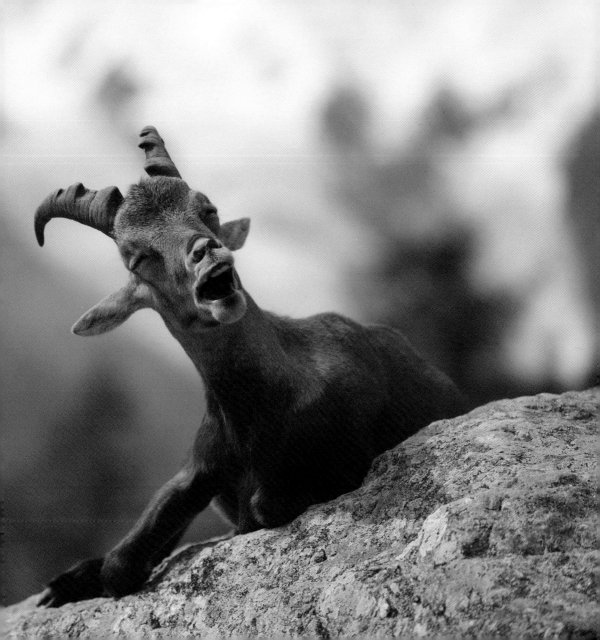

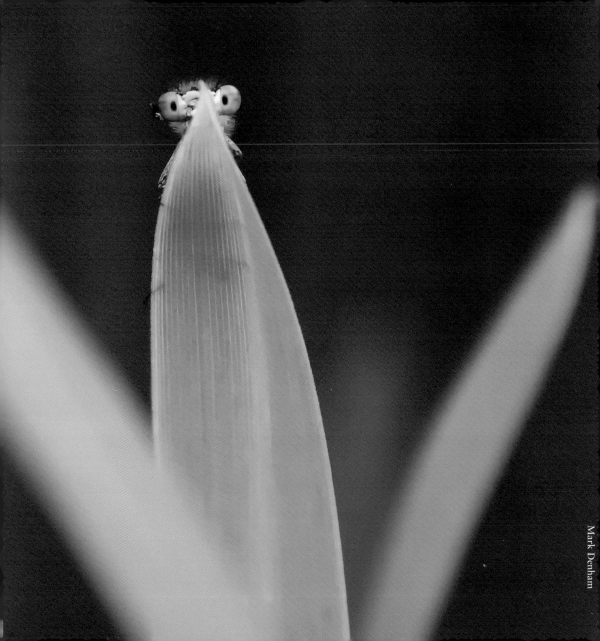

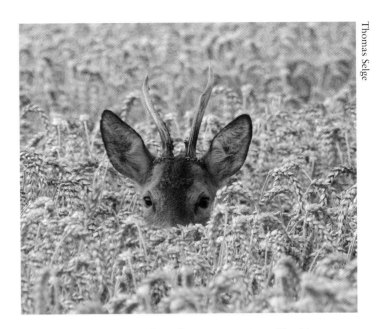

THE BOOK VERSION of Bambi was a Roe Deer, like this one, but for the film adaptation, the producers requested a White-tailed Deer instead, to make it more familiar to a US audience.

DAMSELFLIES like this Goblet-marked Damselfly are renowned for their elaborate courtship behaviours. This chap seems to be playing hard to get.

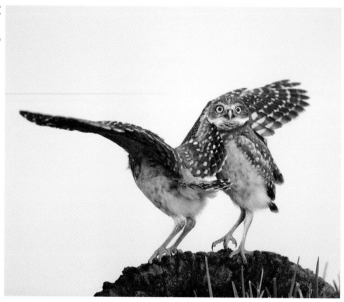

THESE BURROWING OWLETS have distinctive long legs, which they use to chase prey on the ground. The one on the left has chosen a more immediate method of transport though, suggesting that the chap on the right won't be getting a second date.

A TANTALIZING ROSE HIP is no match for this European Ground Squirrel, who has clearly been working out at the gym. Sadly, it is now listed as Vulnerable by the IUCN due to habitat loss.

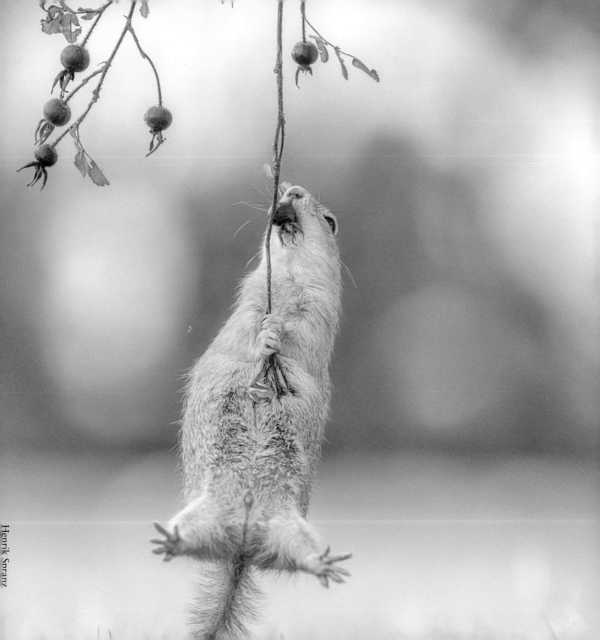

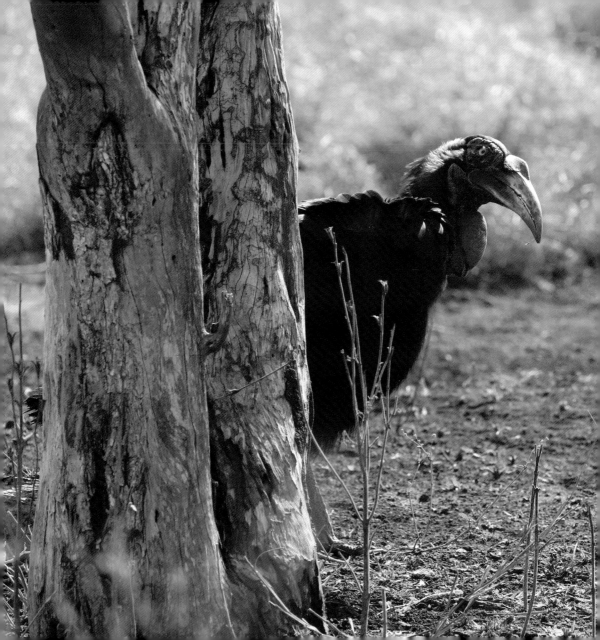

THE SOUTHERN GROUND HORNBILL has three distinguishing features, one of which is untrue. It has vivid red patches of skin on its face and throat and a helmet-like straight black beak. It also has legs like tree trunks that are taller than the bird itself.

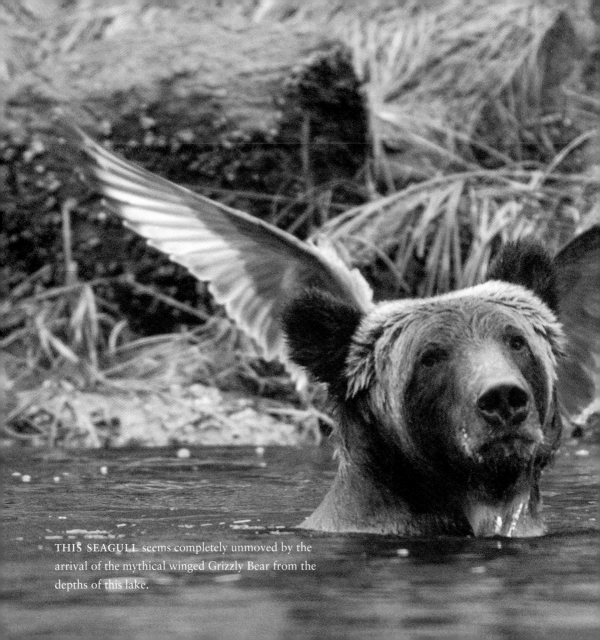

THIS SEAGULL seems completely unmoved by the arrival of the mythical winged Grizzly Bear from the depths of this lake.

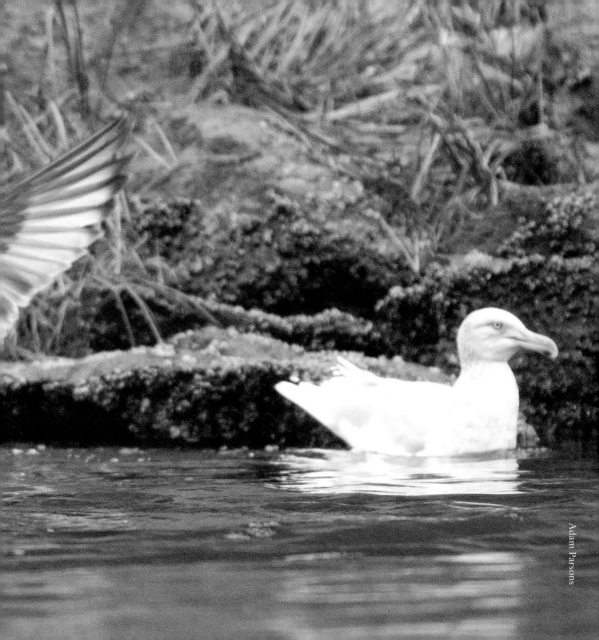

THE HUNT in all its glory…
an epic Red Fox faceplant.

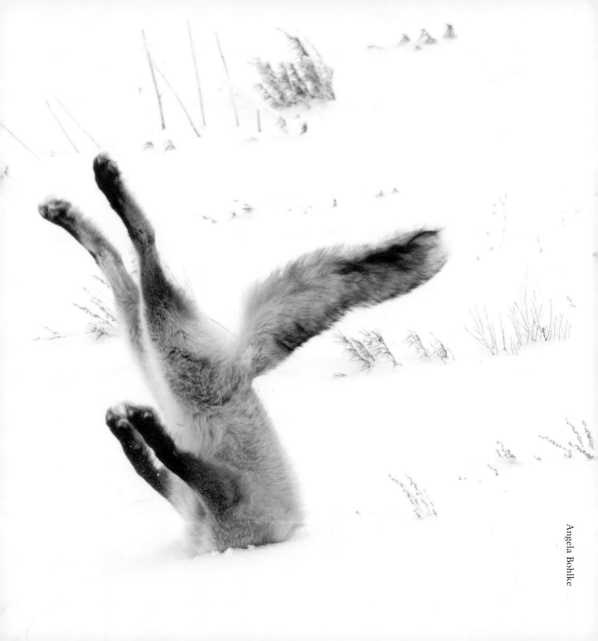

Angela Bohlke

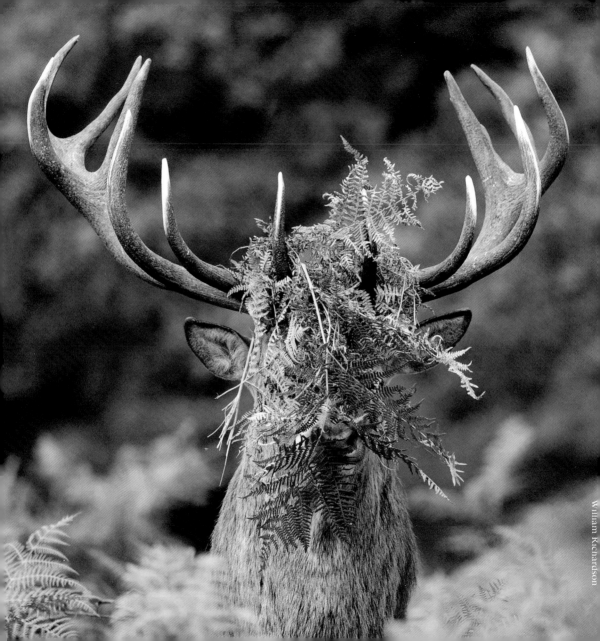

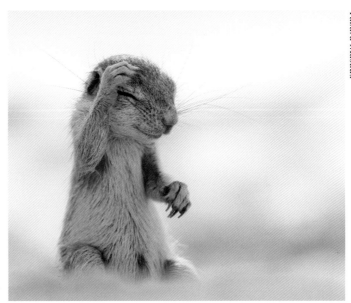

Yuzuru Masuda

THE CAPE GROUND SQUIRREL'S daily routine comprises 70% feeding, roughly 20% keeping lookout, 9% socializing and 1% remembering that he'd left the gas on.

THIS RED DEER takes a safety first approach to camouflage. And when the coast is clear, well, lunch is served!

THE LITTLE OWL'S long legs make it an excellent sprinter, although this one looks like he's competing in the Triple Jump.

Austin Thomas

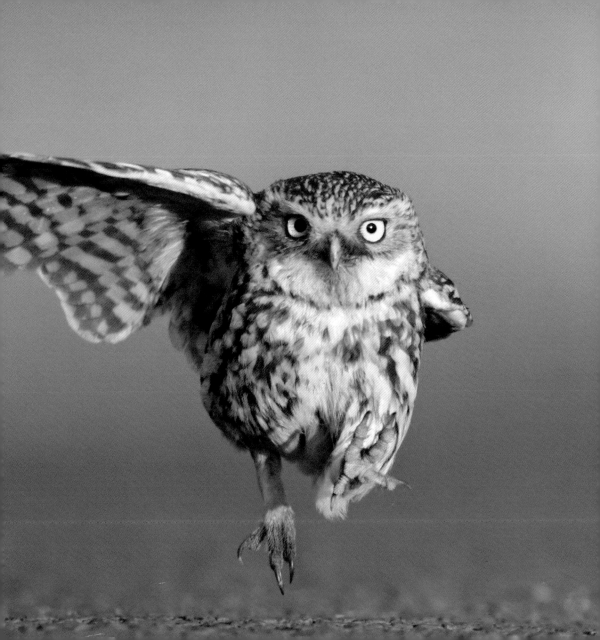

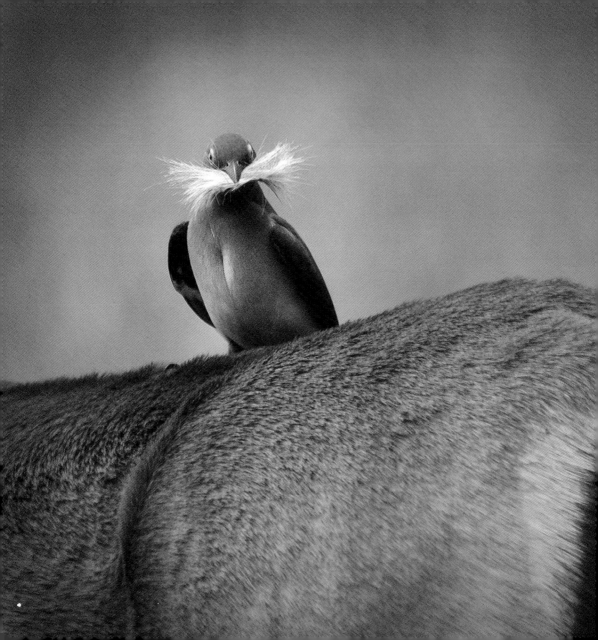

Barrie Walsh

THIS SAVANNA-DWELLING Oxpecker was getting tired of the same routine, so he thought he'd mix it up with a hipster moustache.

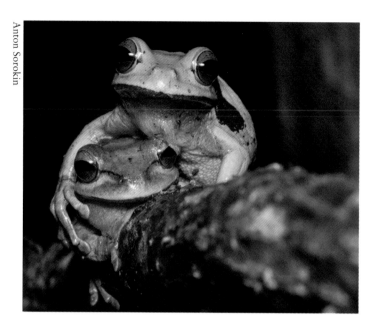

Anton Sorokin

THIS TREE FROG has had a terrible day and needs to be cheered up by her bestie.

KOMODO DRAGONS could well be the one surviving species of a much larger family of giant lizards, who all died out in the last Ice Age. It seems that they've now evolved to the point that they can use public toilets by themselves.

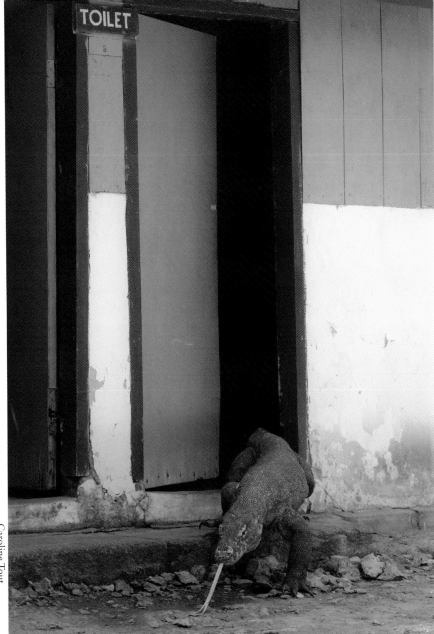

TOILET

THE CHEETAH, stalking the savanna with its characteristic stealth, poise and grace. Sort of.

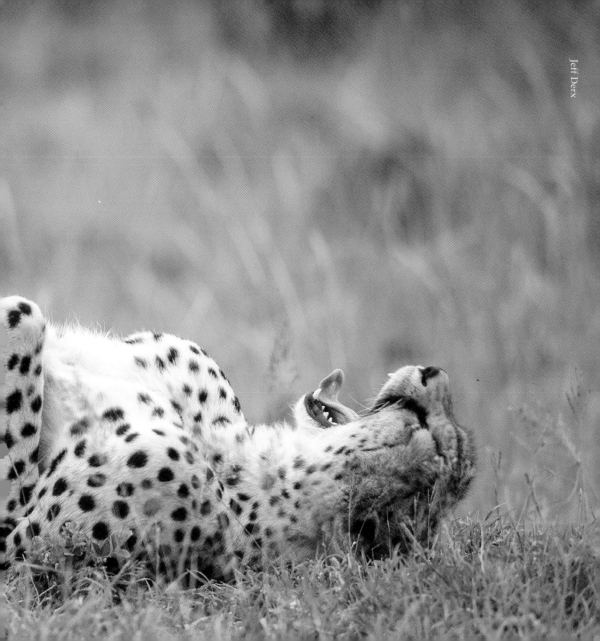

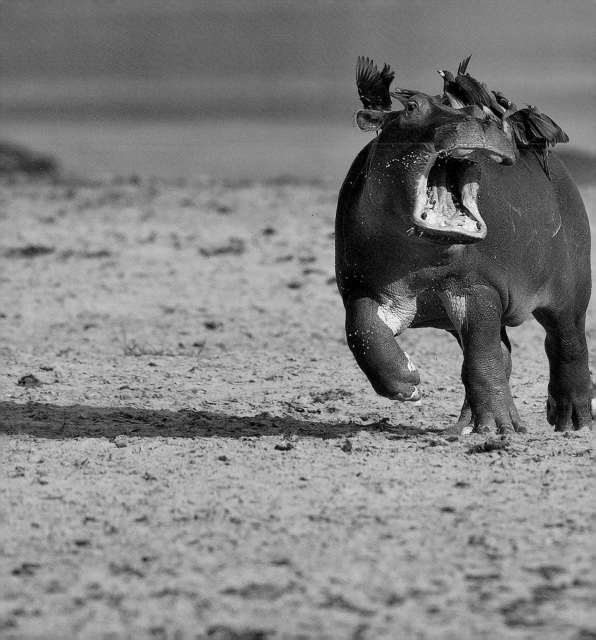

THIS YOUNG HIPPO makes his attitude to unsolicited photographers very clear. If in doubt, scream and run away wildly, and at a top speed of 45 km/h (30 mph), it's usually pretty effective.

Marc Mol

AN ANT can often lift up to 20 times its own body weight, so I'm guessing that this naughty fella is going to be launched some distance.

Usman Piryona

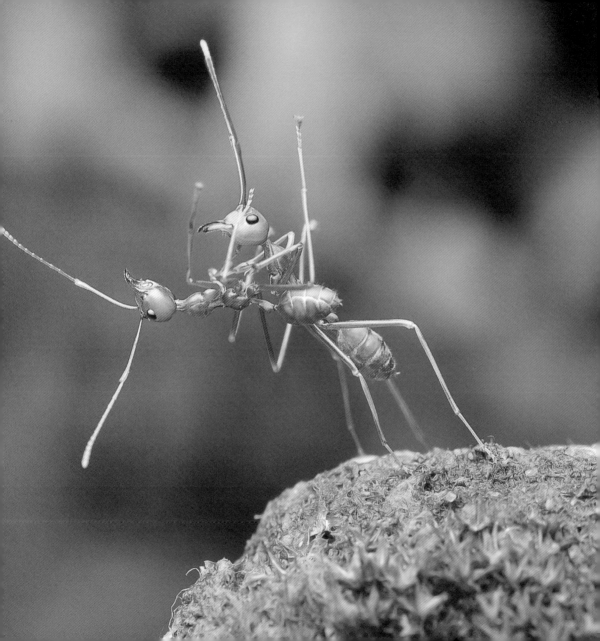

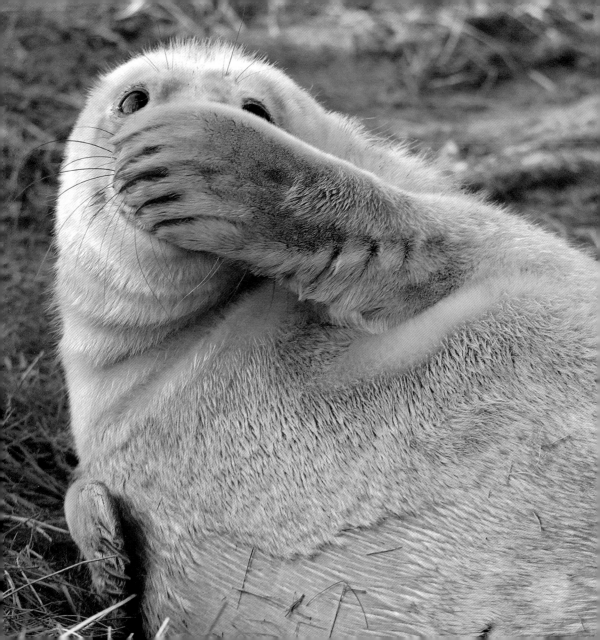

Jason Riley

THIS COMMON SEAL is a solitary creature, but it's clearly been brought up well, having learned to cover its mouth when it sneezes.

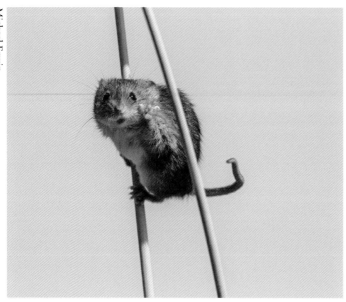

WEIGHING IN at around 10 g (1/3 oz), a Harvest Mouse can grip stems with each foot, making them look like they're using stilts. Most of them don't wave at the camera with their front feet, though – that's just showing off.

A EUROPEAN BROWN BEAR goes out for his early morning run. They can actually reach up to 48km/h (30 mph), compared with Usain Bolt's top speed, which is around 43km/h (27 mph).

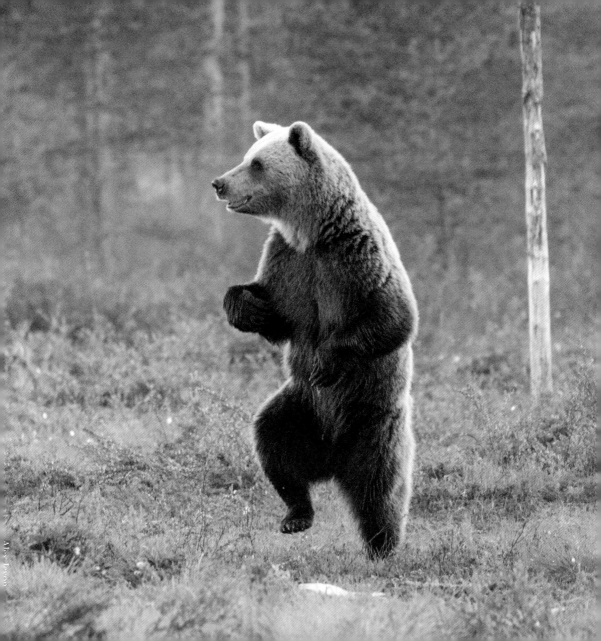

AN AFRICAN LION proving that it's not just Spotted Hyenas that enjoy a good giggle on the savanna.

Usman Piryona

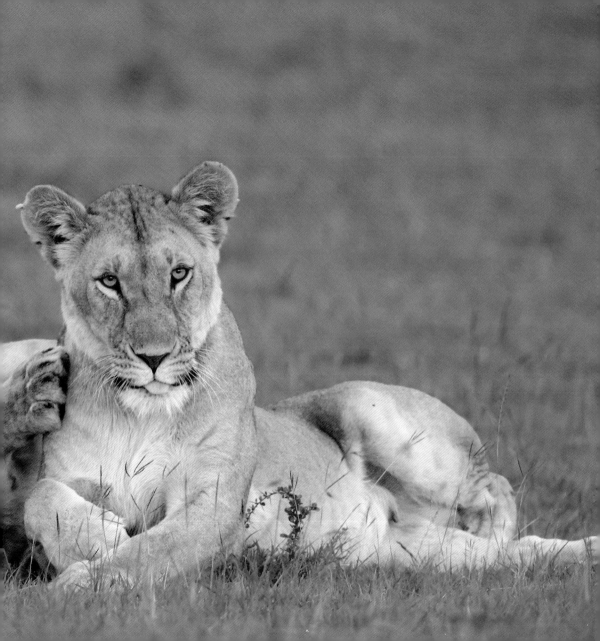

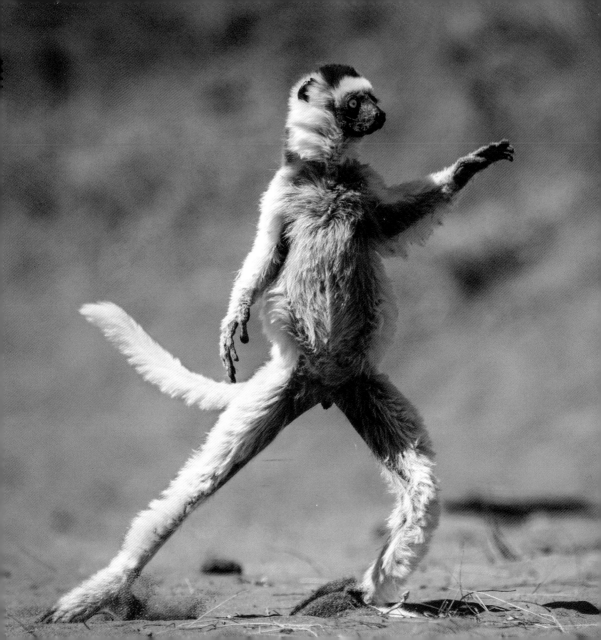

Alison Buttigieg

ONLY FOUND on the island of Madagascar, the Sifaka is an acrobatic, agile species of lemur, renowned for its *Saturday Night Fever* impression.

THE GIRAFFE is the tallest terrestrial animal. This one seems a bit self-conscious of his height, though, so he's created a cunning papier-mâché extra head to make him feel taller.

Janet Miles

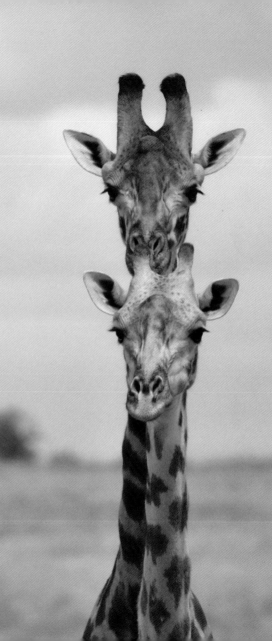

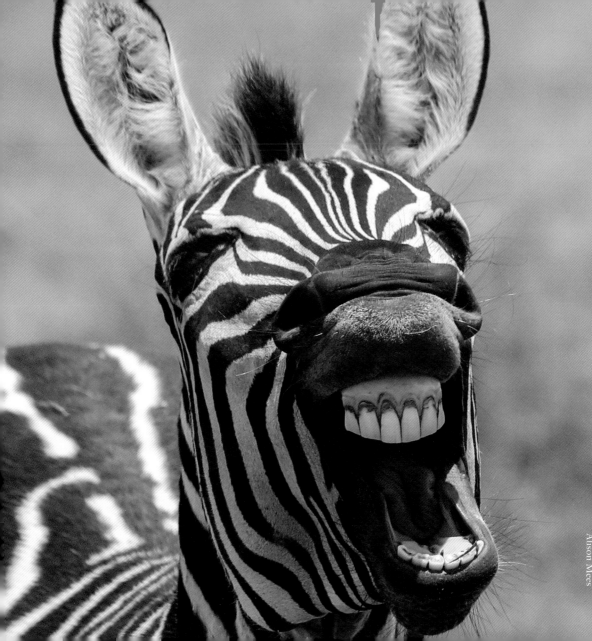
Alison Mees

THE WANDERING ALBATROSS has the longest wingspan of any bird, with some reaching 3.5 metres. This one is checking his reflection out in the camera lens – maybe he has a hot date later...

ZEBRAS are technically black animals with white stripes. And they don't like being called horses with pyjamas on, although this might be the first time this guy has heard that gag.

WHATEVER THE JOKE this Common Seal has just heard, he's certainly giving it the seal of approval.

Julie Hunt

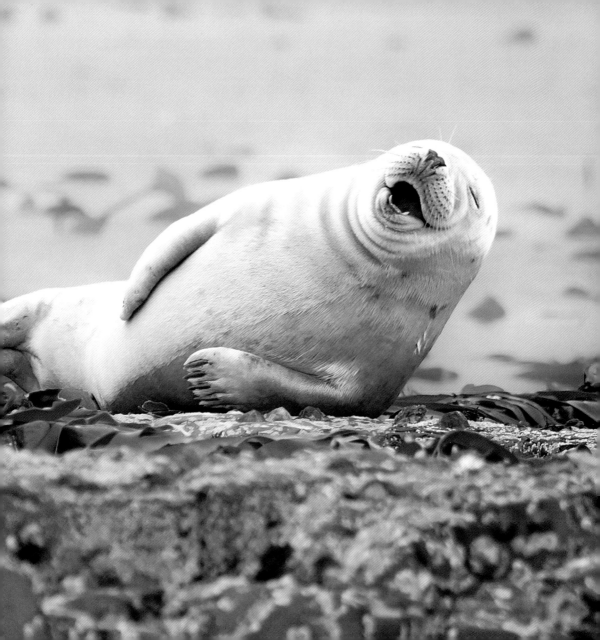

THESE SPOTTED SEALS were all performing the
side plank perfectly in their exercise class, but there's
always one joker, isn't there?

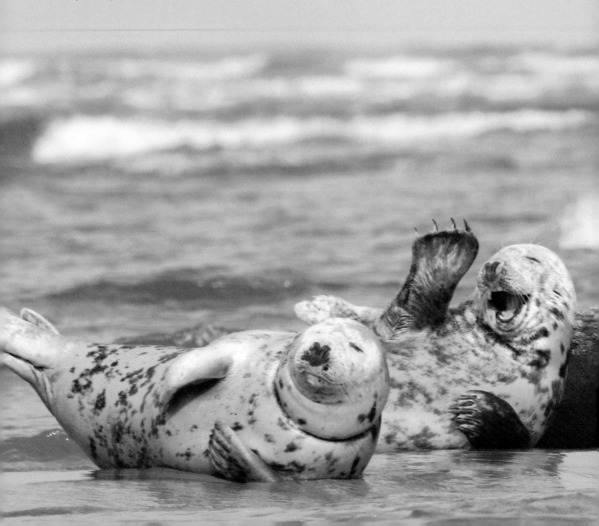

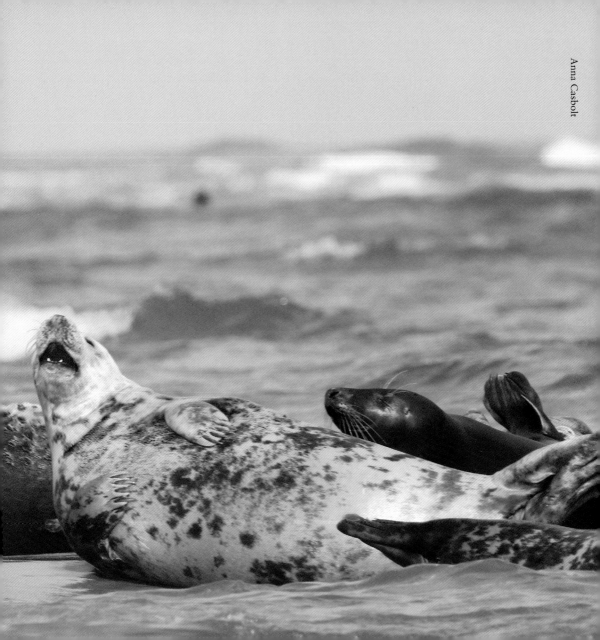

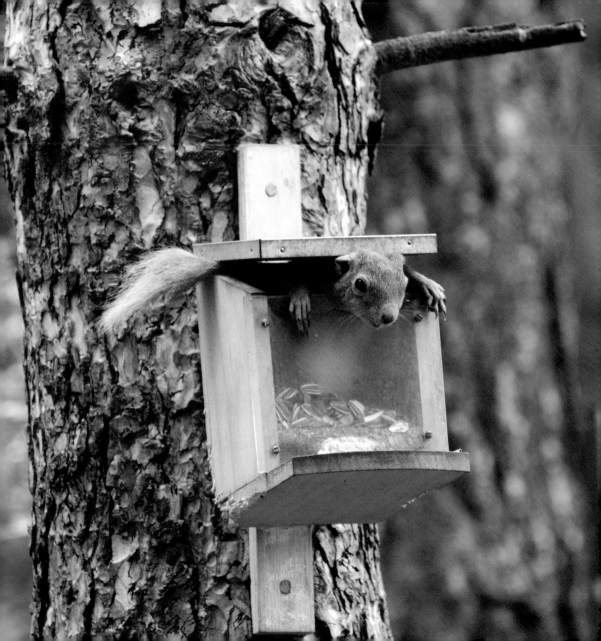

John Brown

'ER – A LITTLE HELP, here, someone?' says this accident-prone Red Squirrel.

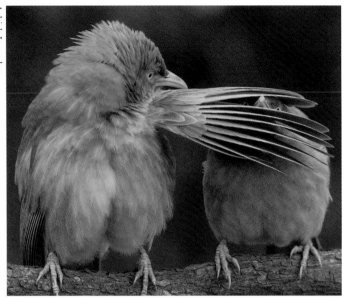

THIS MOTHER JUNGLE BABBLER, a bird common in the Indian Subcontinent, looks like she's shielding her baby's eyes from something not suitable.

THE RED SQUIRREL is protected in most of Europe by law. In the rest of the world, they are protected by Super Squirrel!

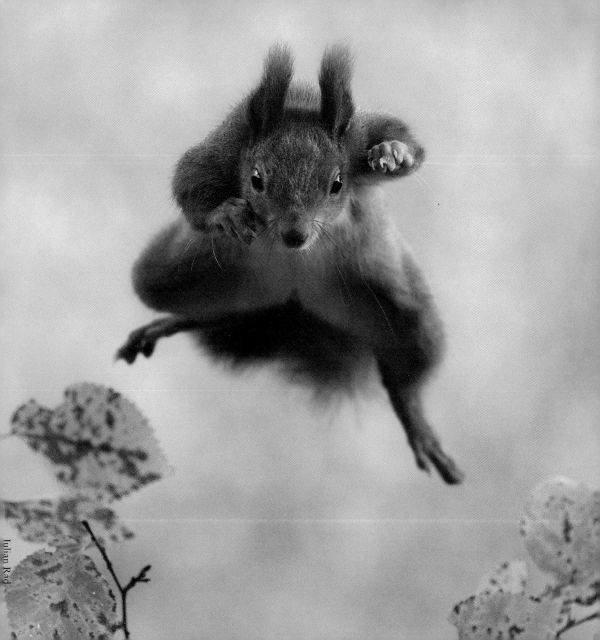

Iulian Rad

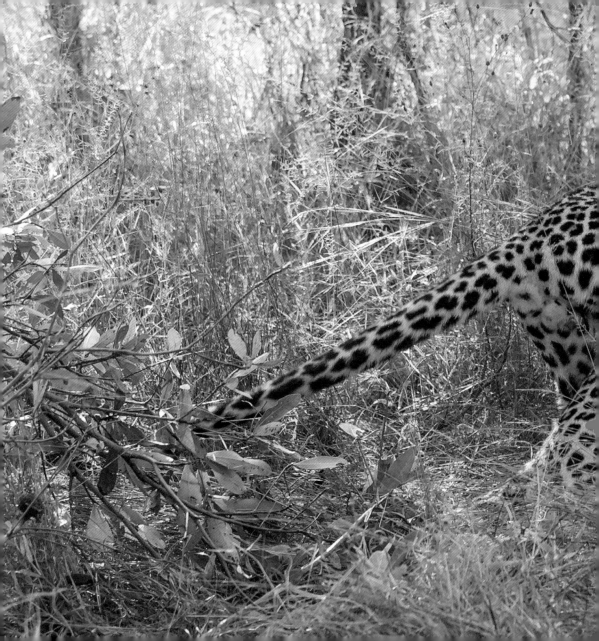

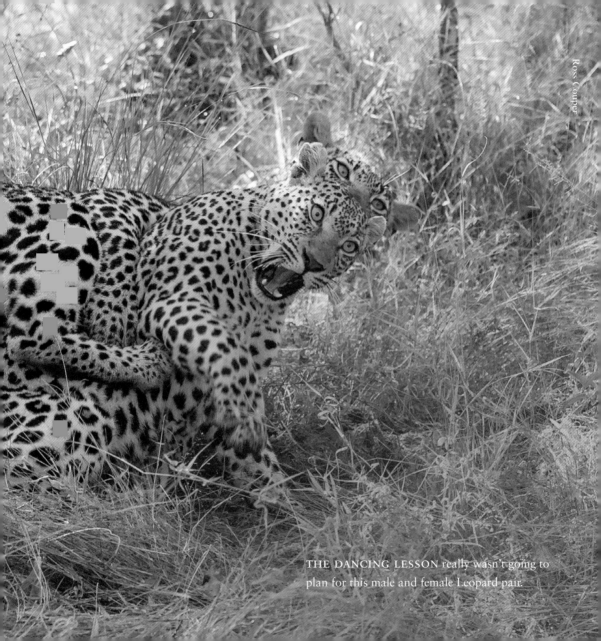

THE DANCING LESSON really wasn't going to plan for this male and female Leopard pair.

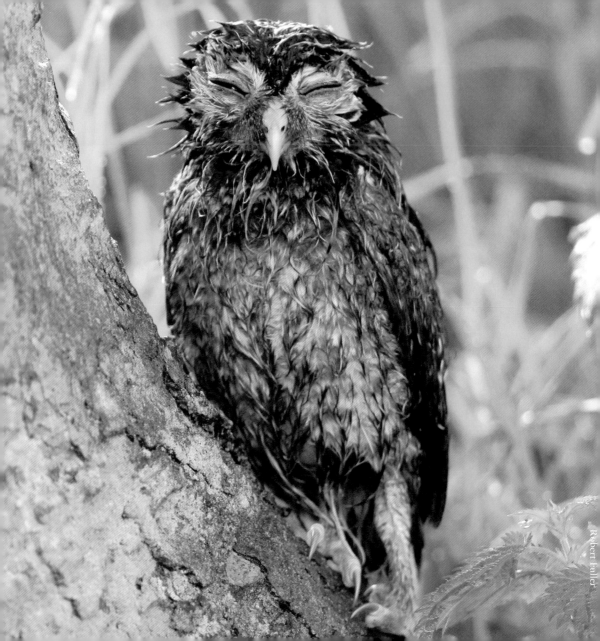

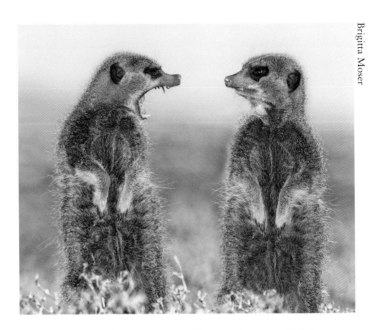

MEERKATS are plant-eaters as well as omnivores, which is probably why this one's asking his friend if he has anything stuck in his teeth.

OWL BE seeing you tomorrow, after some shut eye, says this utterly drenched Tawny Owl.

ACHIEVING SPEEDS of up to 113 km/h (70 mph), the Cheetah is the fastest land animal, but sometimes it's just easier to call a cab to chase that pesky antelope.

Marc Mol

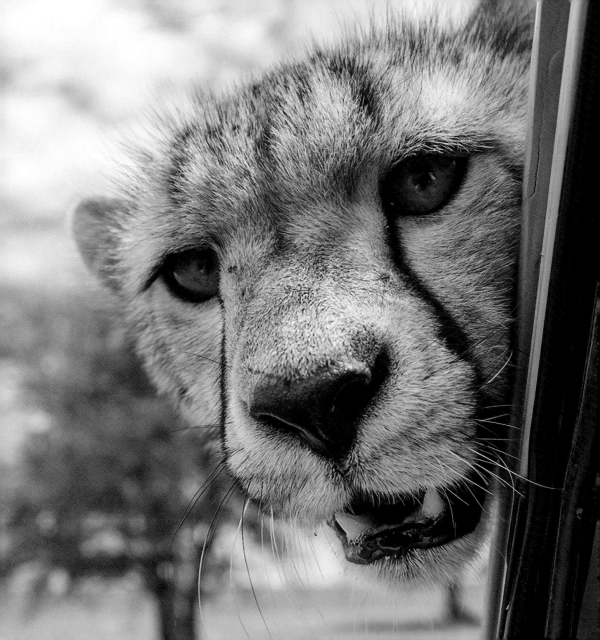

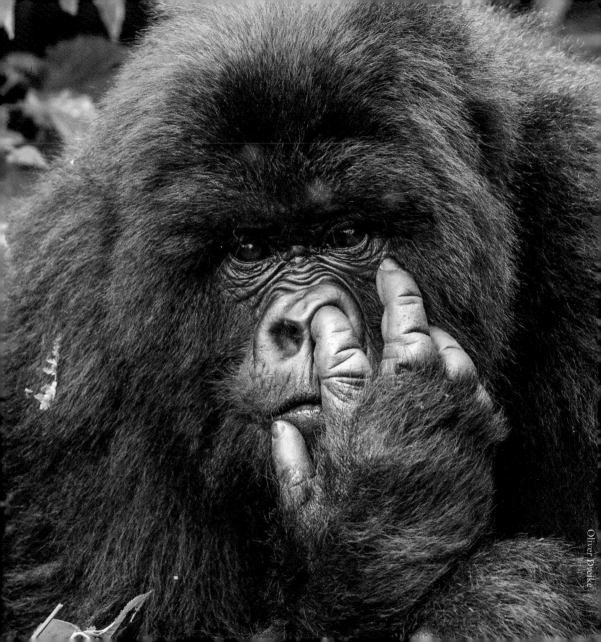

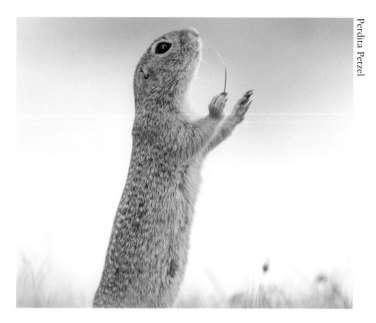

AT HIS FIRST WAND LESSON at Hogwarts, this European Ground Squirrel learns the spell 'Wingardium Leviosa'.

THIS INDIVIDUAL'S cheeky nose picking shows that humans really aren't that dissimilar to the Western Lowland Gorilla...

IT'S JUST A good job that Grizzly Bears' diets
include up to 80% plant matter...

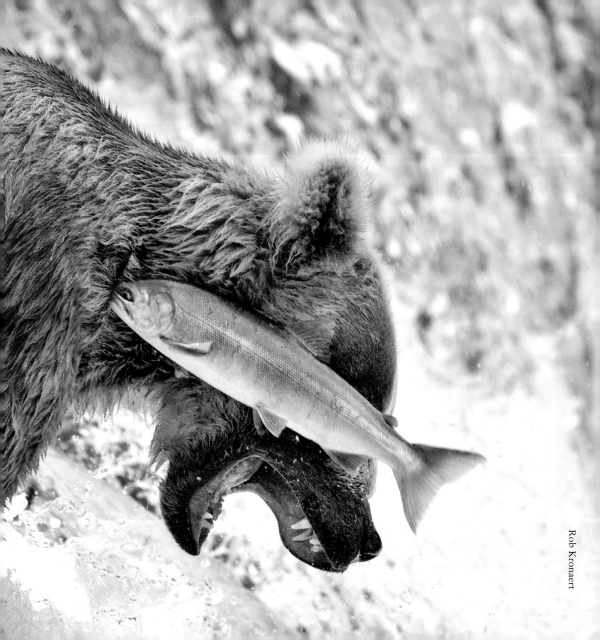

Rob Kronaert

JAPANESE MACAQUES are well known for their ability to learn new behaviours, like bathing in hot springs to escape the winter cold. This baby one has learned a rather more mischievous pasttime, though…

Nicolas de Vaulx

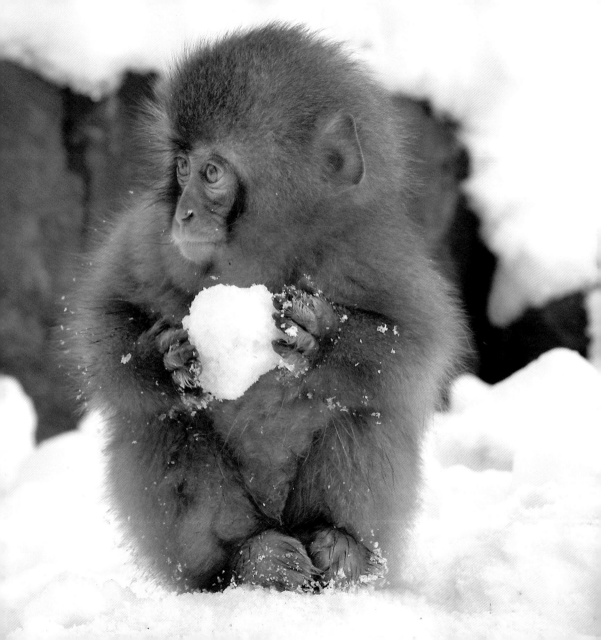

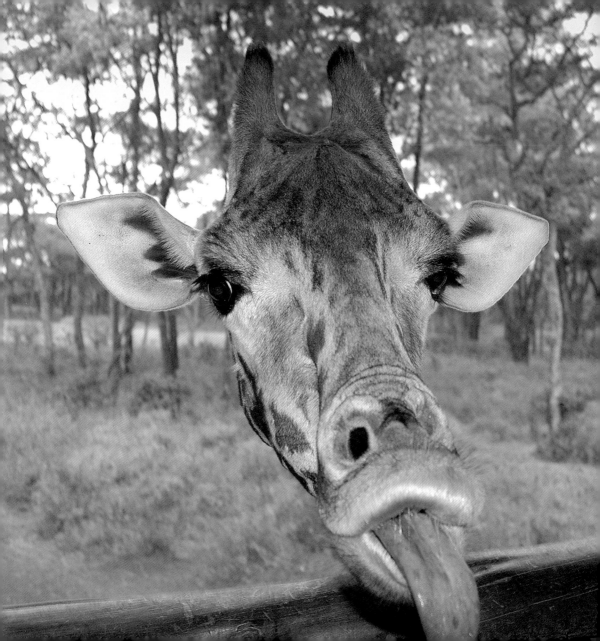

Stephen Biddlecombe

A GIRAFFE'S TONGUE can measure up to 50 cm (20 inches). It's black in colour to prevent it from getting sunburnt and it's tough enough to deal with thick thorns. But mostly it just uses it to annoy tourists.

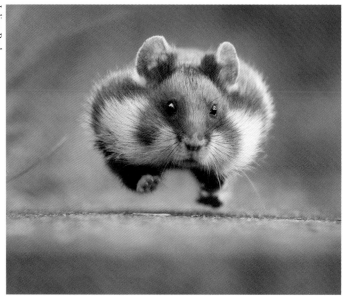

HAMSTERS CAN store food for later in cheek pouches, which can increase the size of their head by two or three times. They just hope that something doesn't chase them after they've gorged themselves. Ooops.

THE CATTLE EGRET usually helps an African Buffalo out by eating ticks and other insects off its hide. This cheeky egret doesn't seem that thankful to its host, though. I just hope the buffalo lifts his head up very soon…

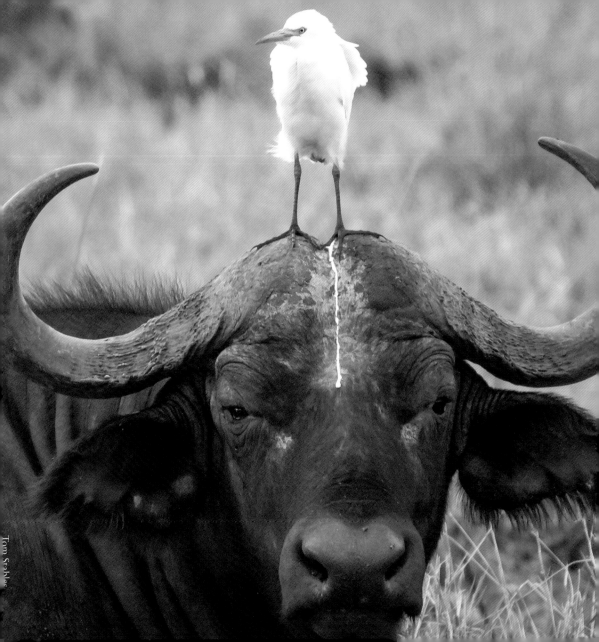

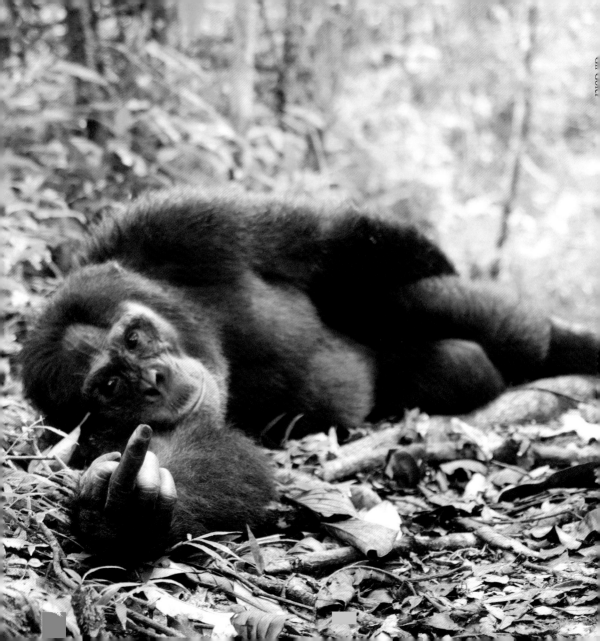

GORILLAS HAVE learned to use tools in the wild and some have been taught a form of sign language by humans. No prizes for guessing what this guy is saying, (*left*).

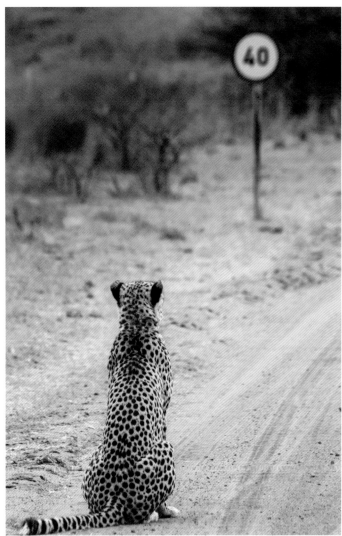

Vaughan Jessnitz

WITH A TOP SPEED of between 110–120 km/h (70–75 mph), this Cheetah is definitely going to be breaking the law. Well, at least there isn't a speed camera.

THIS EASTERN CHIPMUNK may look slightly unwell after decimating the top half of this sweetcorn cob in a few seconds, but she'll keep going, believe me!

Barb D'Arpino

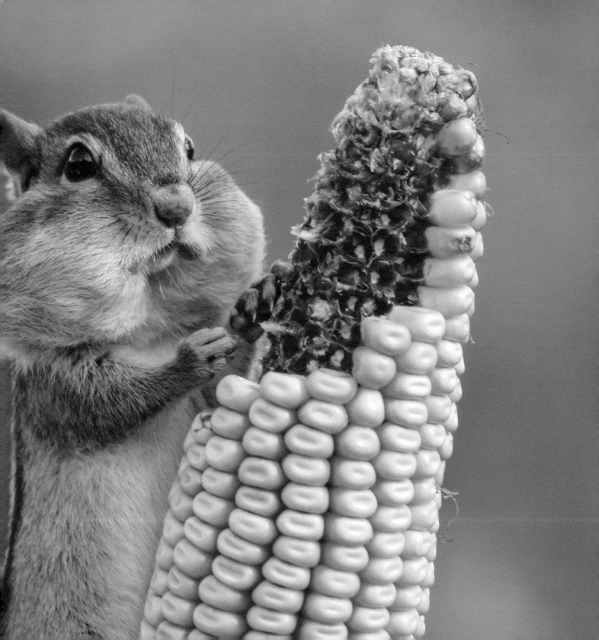

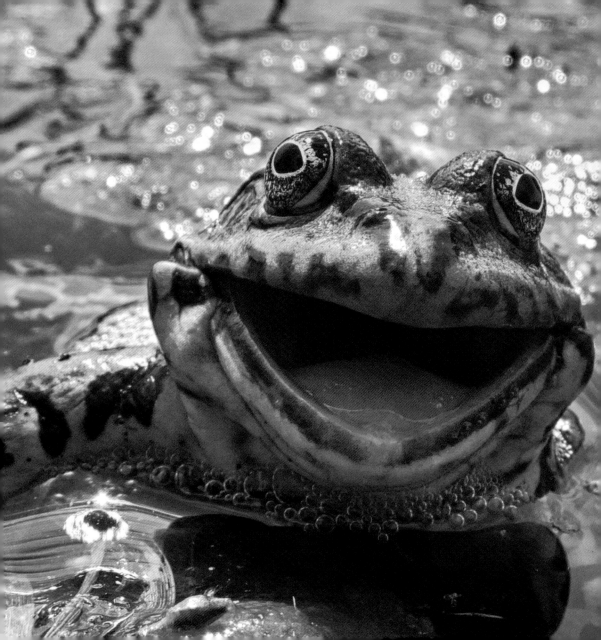

Artyom Krivosheev

THIS RUSSIAN Dark-spotted Frog certainly knows how to pose for the camera.

THE MACAQUE wondered whether he should have got a real dentist to perform a check-up, rather than his friend Marvin.

Simon Linge

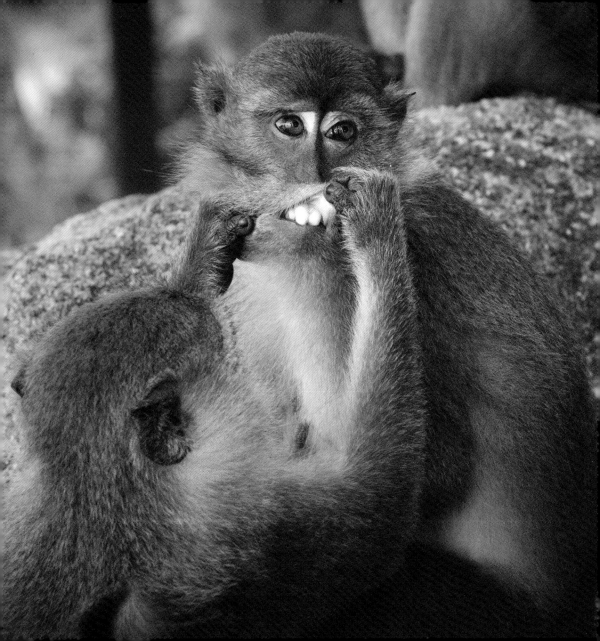

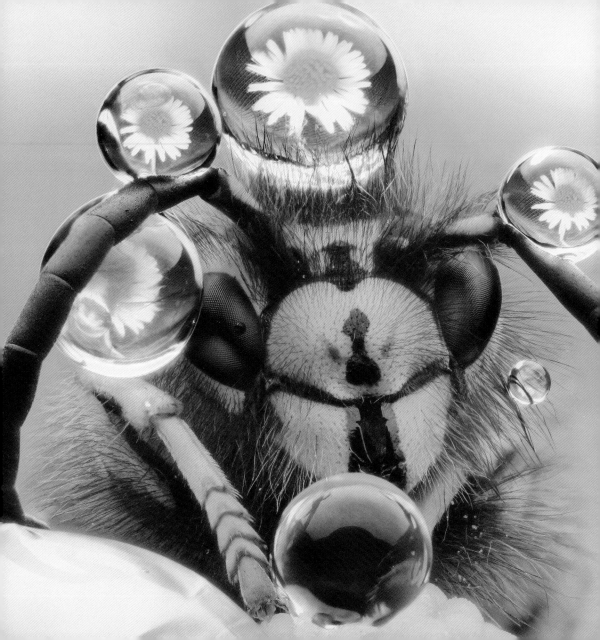

Murray McCulloch

THIS HONEY BEE is modelling the new daisy pearl tiara, part of the Bee in a Bonnet range.

THESE RAINBOW-BILLED PUFFINS can dive down an amazing 60 metres (200 feet) to catch fish, using their feet as a rudder; this one looks like he still has some water in his ear from his last dive, though.

Mary Swaby

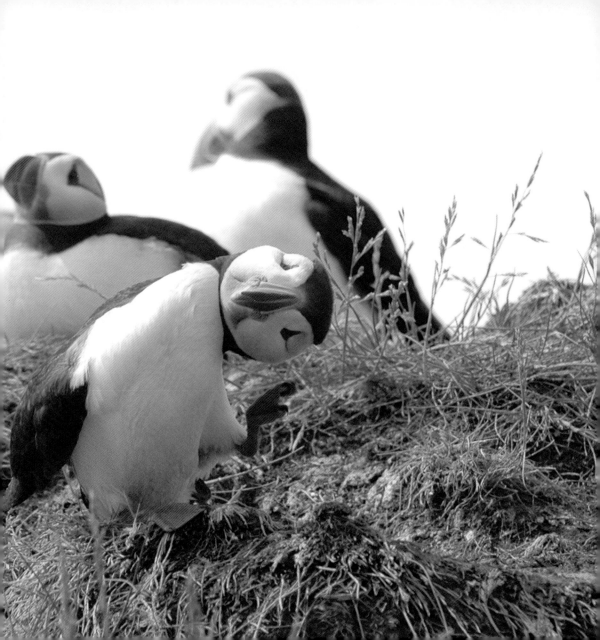

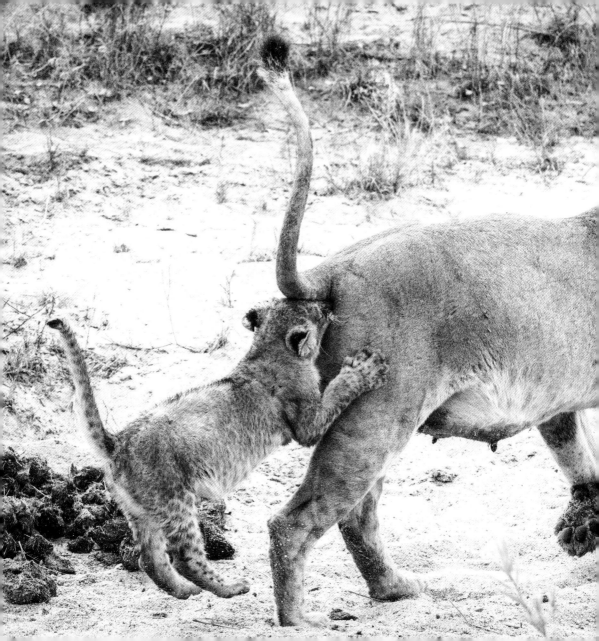

Douglas Croft

THIS AFRICAN LION CUB appears to be bumming a ride.
Not a means of transport he'll choose again, I imagine.

AND THE FIRST EVENT at the mammal vs amphibian Olympics is the much anticipated stare-off. First one to blink loses. However, seeing as a frog has transparent eyelids, he does have a considerable advantage!

Isabelle Marozzo

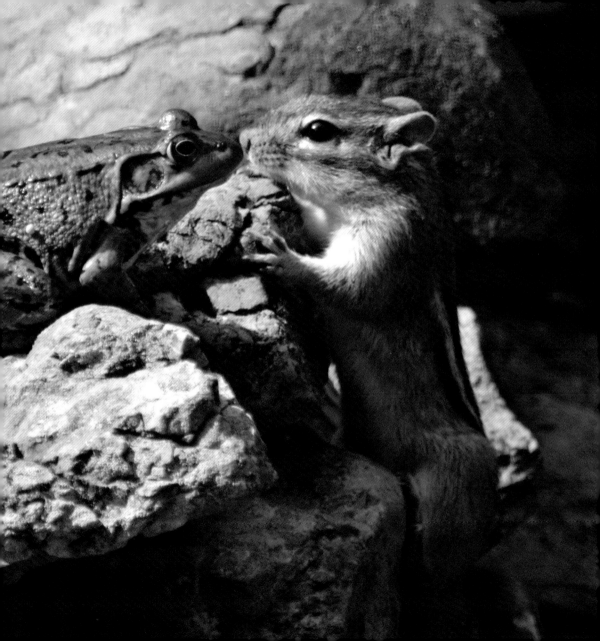

Isabelle Marozzo

FORGIVE ME FATHER, this Red Squirrel seems to be saying. And please make it stop snowing, so I can see my food!

AND THE FIRST LESSON you need to learn my son is never to stand too close to an older elephant's bottom. Elephant dung can weigh in at a hefty 50 kg (110 lbs) a day – the same weight as a slender human.

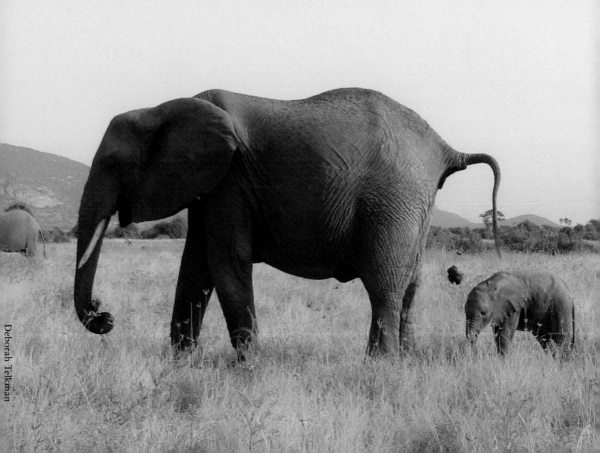

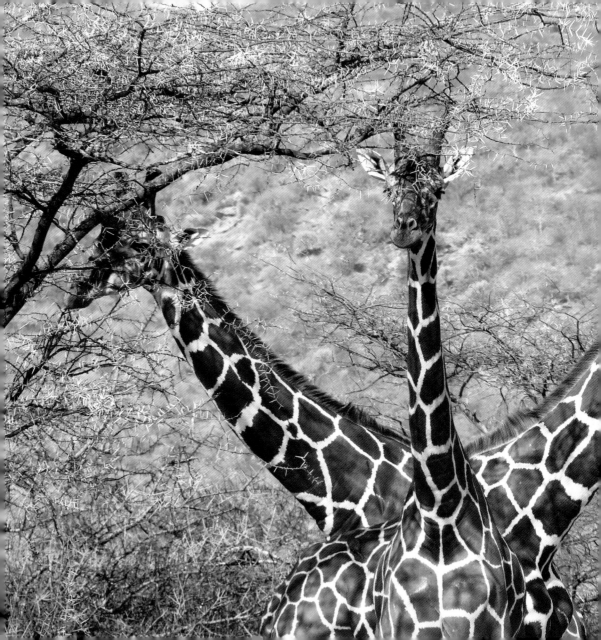

Tony Murtagh

THE UNIQUE THREE-HEADED GIRAFFE. Must have been a fairly difficult labour for the mother, I'd wager.

THIS MALE GROUND SQUIRREL waits patiently for his date, and if she doesn't show up, well at least he's got something to munch on.

Henrik Spranz

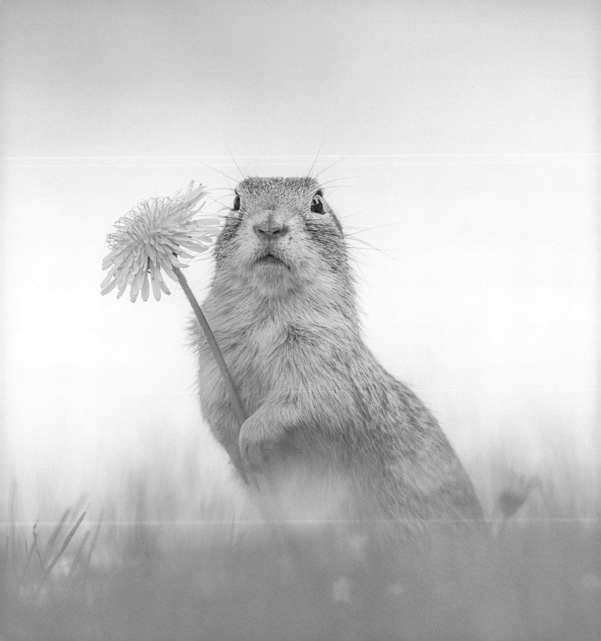

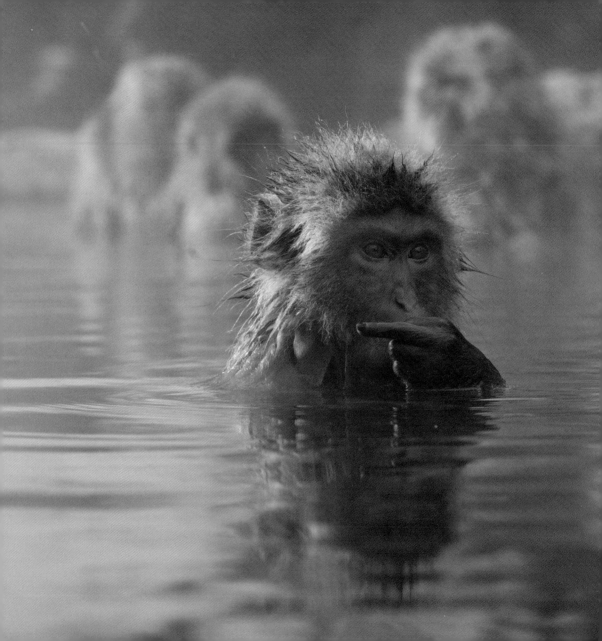

Burkhard Fenner

JAPANESE MACAQUES have learned to bathe in hot springs to warm up in winter. This one seems to be saying 'I know the bubbles came from around here, but it wasn't me who farted...'

Birds of the feeding station

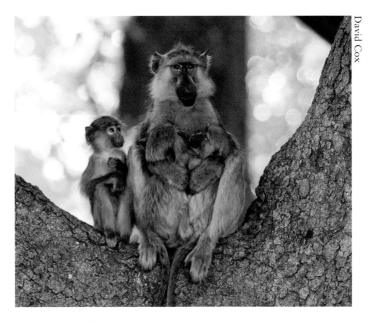

David Cox

ERR MUM, when do I get my turn?

A CONFIDENT ROBIN asserts that there's only one bird
worth feeding in this patch.

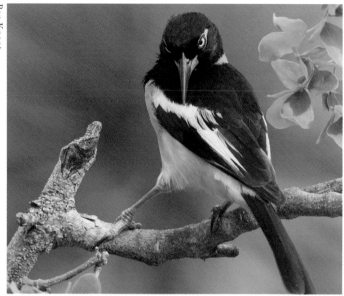

THIS VENEZUELAN TROUPIAL is the national bird of Venezuela. And if striking a catwalk-like pose like that doesn't get him a mate, I don't know what will.

THIS HIMALAYAN TAHR is a species of wild goat with a mane that a lion would be proud of. You can almost hear him blowing a raspberry at you.

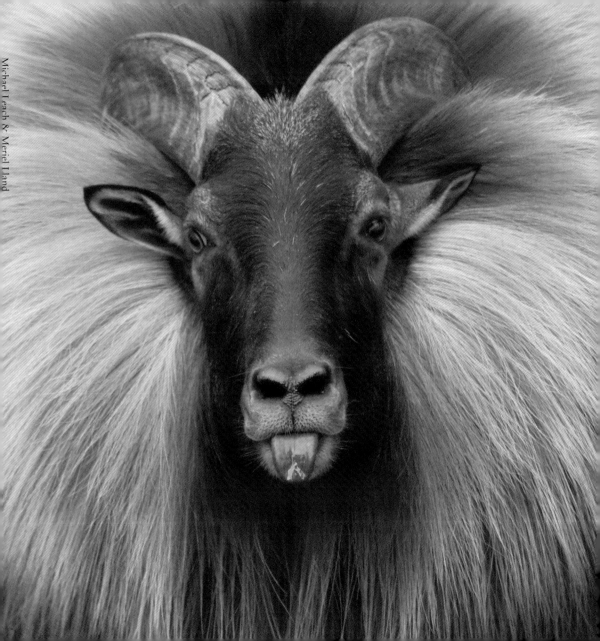

CURIOUSLY, THIS SEAL seems to be replicating the Navy SEAL training programme, which genuinely involves somersaulting into the water and swimming 50 metres (165 feet under the surface. Well that test is in the bag for this fella.

Ben Knoot

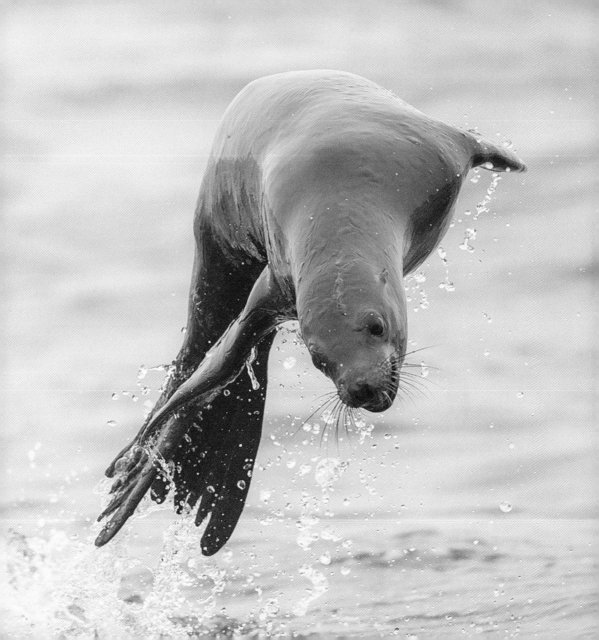

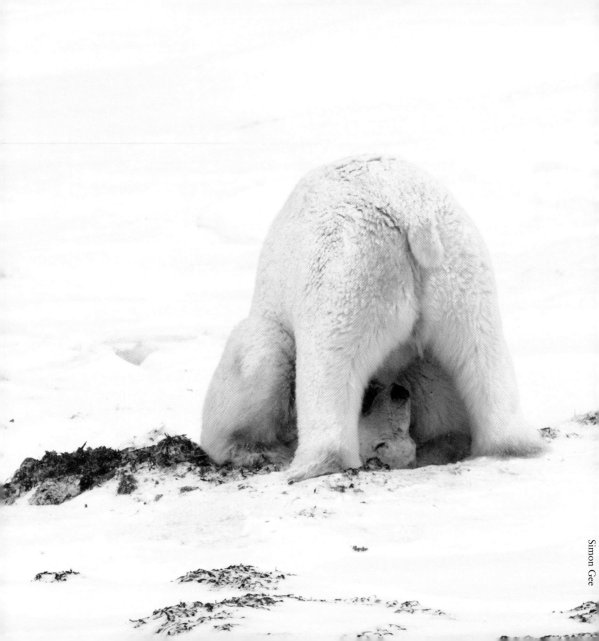

THIS BLACK-BELLIED whistling duck is really putting his neck on the line. Go on, my friend. Smash the system.

Bill Gozansky

AT A WEIGHT of around 410 kg (900 lbs), when a Polar Bear moons you, you know about it, (*left*).

113

A SOLITARY KAMCHATKA BROWN BEAR, the largest bear in Eurasia, meditating in particularly zen fashion. If only he was performing the Bear Yoga pose…

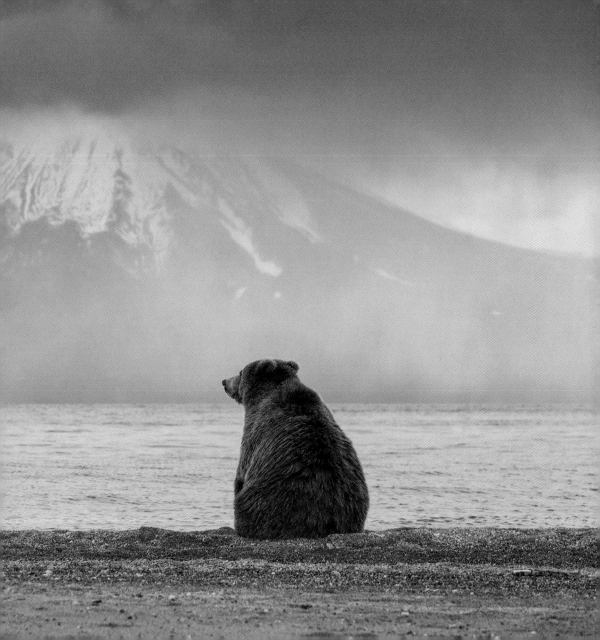

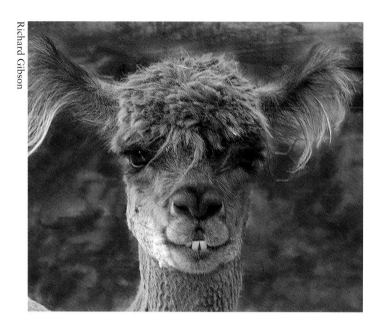

Richard Gibson

THE SOUTH AMERICAN ALPACA is renowned for its ability to spit at predators and for rocking the *out of bed* look.

A UGANDAN KOB, a species of antelope with distinctively large ears, adopts a unique approach to camouflage: *If I can't see them, they definitely can't see me...*

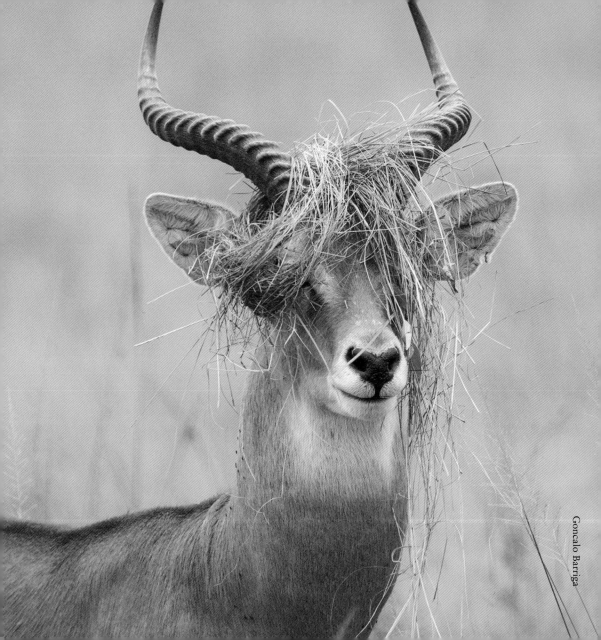

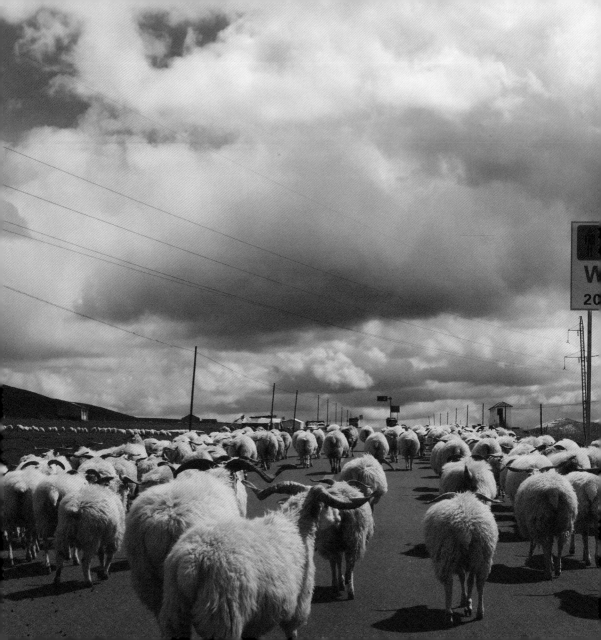

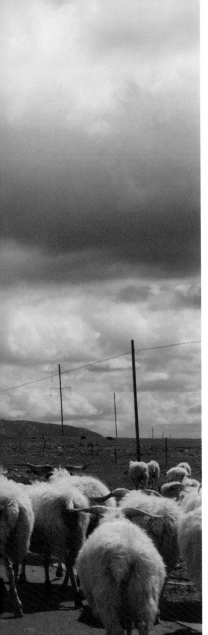

Iris Wood

I RECKON ONLY THE SHEEP at the front of this column actually needs to go to the WC, and the others are just doing what they do best.

'EVERYBODY LOOK LEFT, everybody look right,
everywhere you look we're standing in the spotlight.'

Delian Tong

NOT ONLY have these Black Bear cubs nabbed the latest GoPro camera from an unsuspecting wildlife photographer, but now they're learning to take selfies, too!

Megan Lorenz

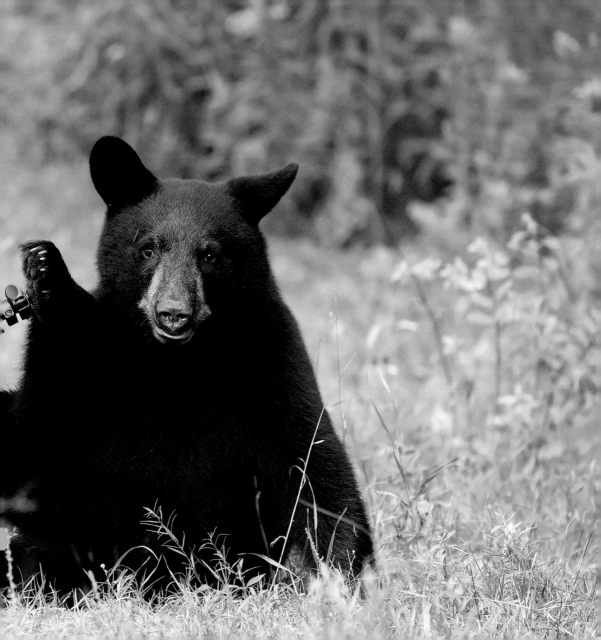

THIS VAIN LITTLE MONKEY is checking that his hair is just right in this car's wing mirror. I have a feeling that mirror may be coming with him…

Cristina Scalzi

124

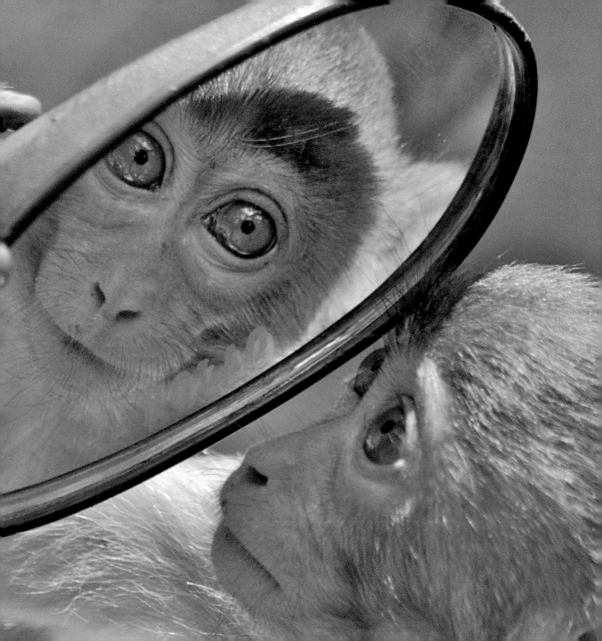

Kirsten Frost

I'M STICKING my neck out here but I think that's a Squacco Heron.

AN ENDANGERED MALE Ring-tailed Lemur doing his best to appeal to the ladies.

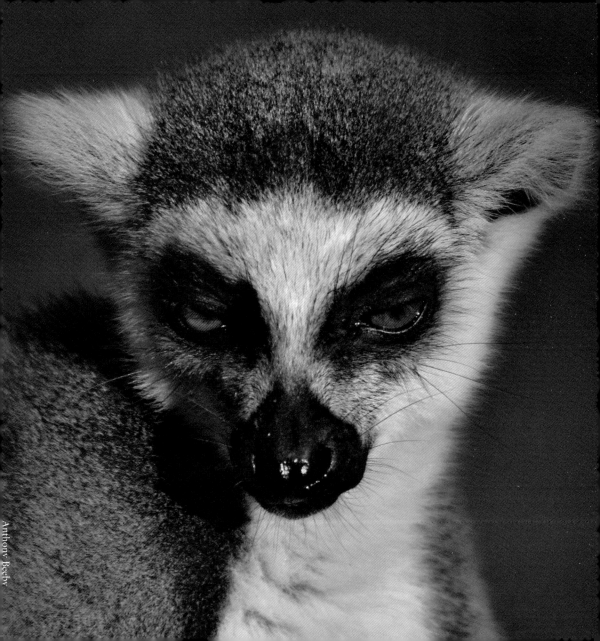

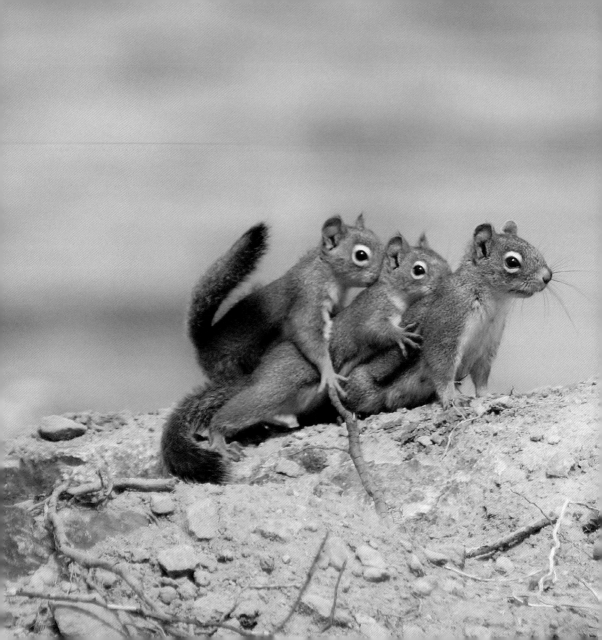

AMERICAN RED SQUIRRELS grow so quickly that this mother is regretting asking the question 'Who wants a piggyback?'

Yvette Richard

SOME LADYBIRDS can attain the same speed as a racehorse and reach heights of up to 1,100 metres (3,600 feet). It looks like this one has rather misjudged its takeoff plan, though.

Femke Warmer

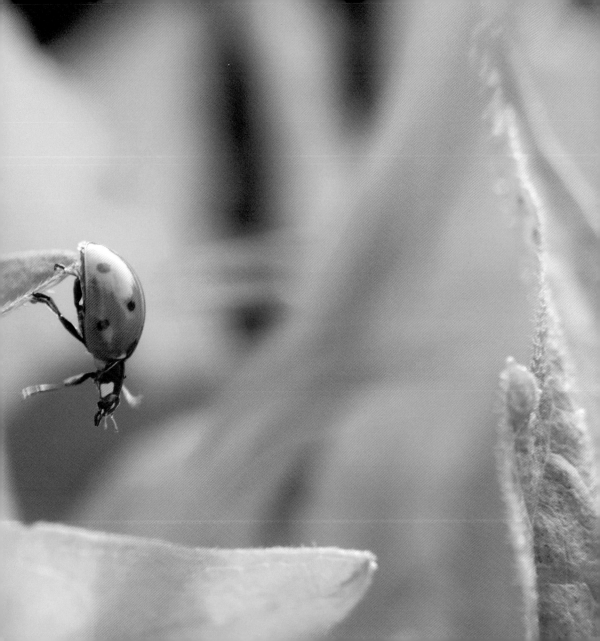

THIS PRIDE is just lazily lion around
on a handy cool rock.

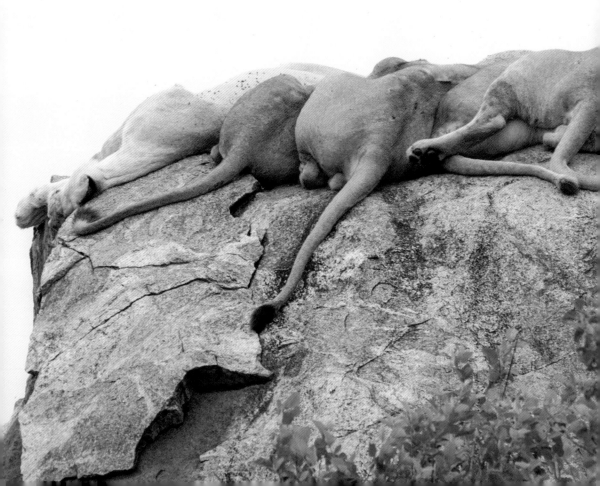

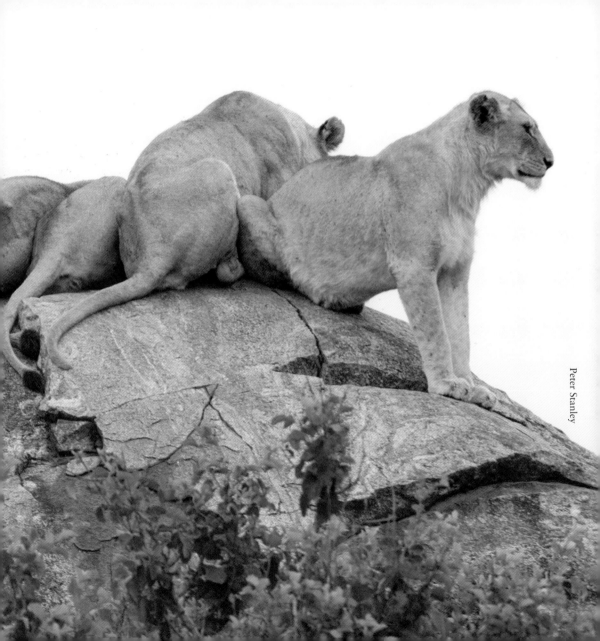

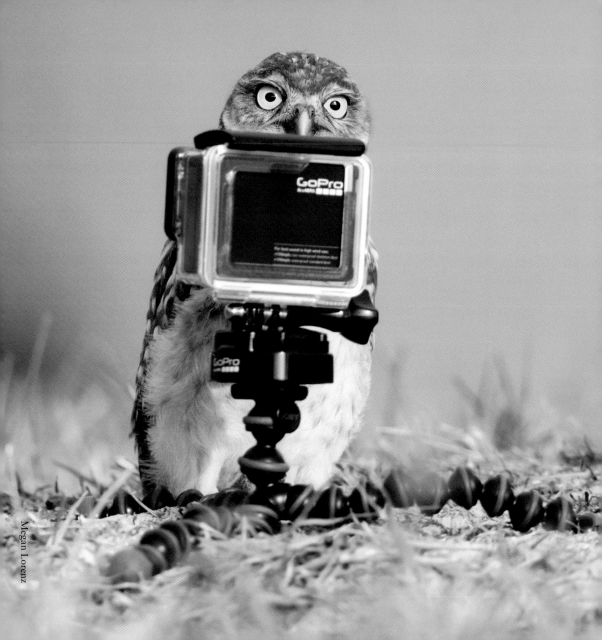

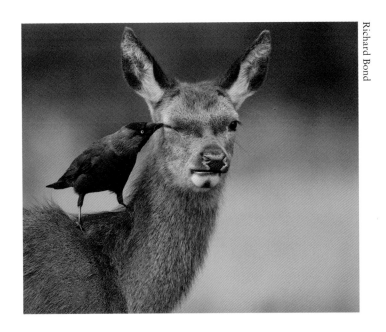

THIS FEMALE RED DEER has her very own personalized grooming service, with this handy Jackdaw removing ticks. And what does the Jackdaw get in return? A tasty snack.

IT MUST BE BREEDING SEASON, because this inquisitive Burrowing Owl is desperate to help the camerawoman make sure she gets his best side.

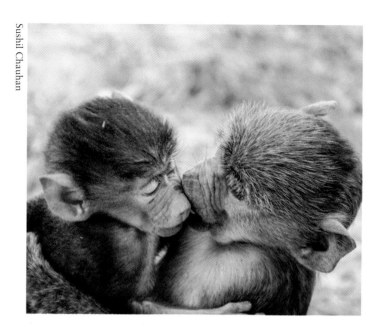

YOUNG MALE AND FEMALE Olive Baboons often form long-lasting intimate friendships. This chap on the right, though, is clearly trying his luck.

THESE BABY EURASIAN POLECATS – the only ancestors of the ferret – have developed the perfect response to an unsolicted knock at the door.

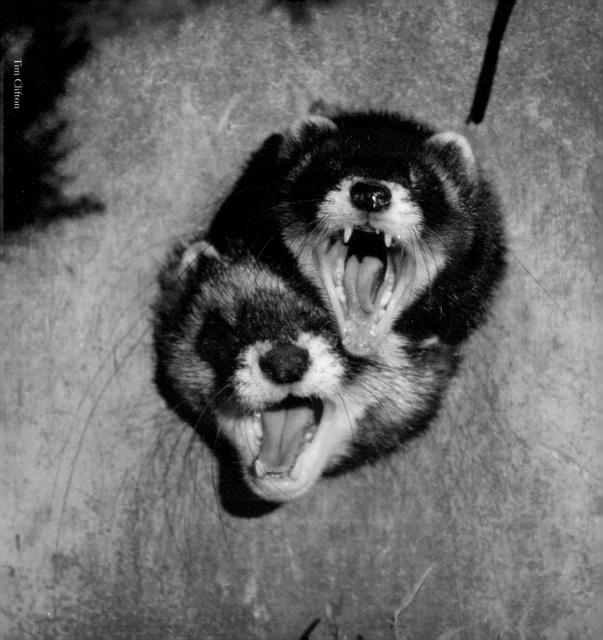

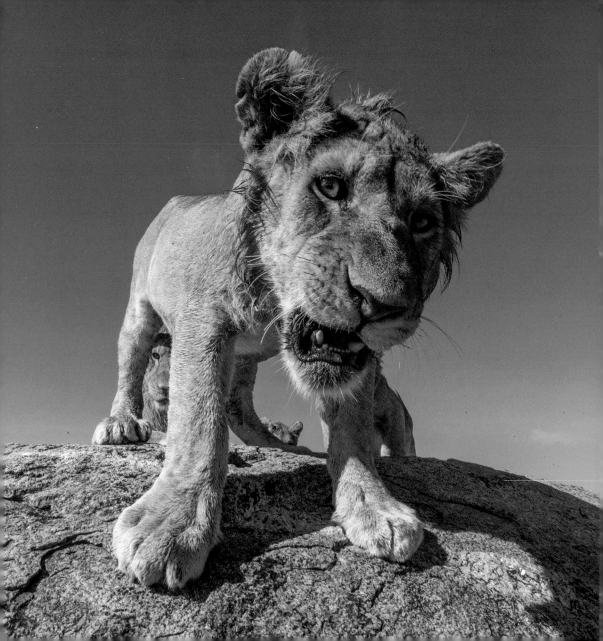

SIMBA KEPT returning to Pride Rock but now that he was around 80 kg, no monkey wanted to lift him in the air anymore.

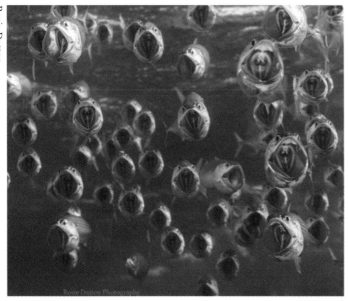

AND THE WINNER of the Pac-Man imitation contest goes to this school of Indian Mackerel.

THE AFRICAN ELEPHANT can carry up to 350 kg with its trunk and can hold up to 8.5 litres of water inside it. They also make great hoovers, as demonstrated here.

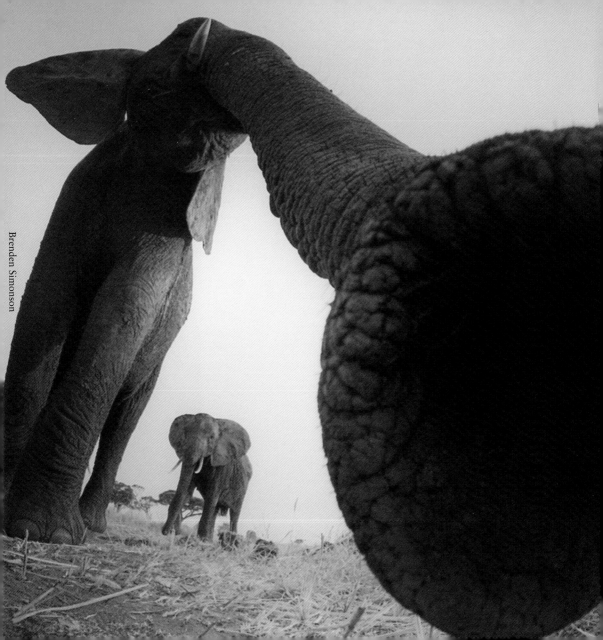

THE BLACK-BROWED ALBATROSS can live for up to 70 years in the wild. They feed on fish, squid and crustaceans. And whole albatrosses, apparently…

Phillip Marazzi

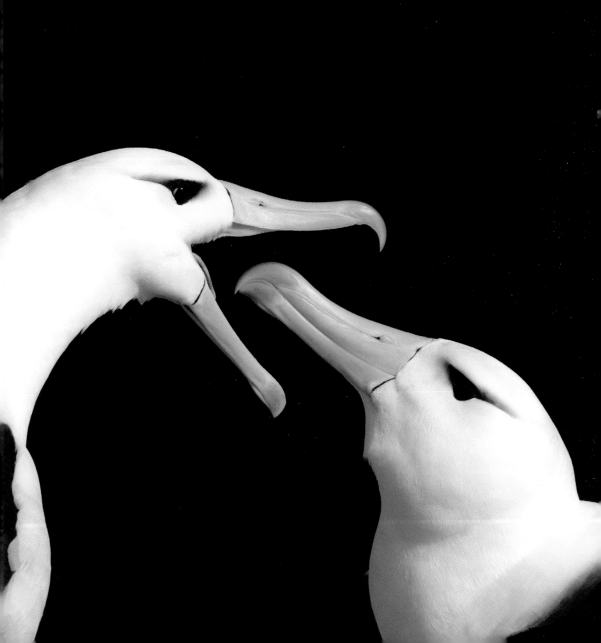

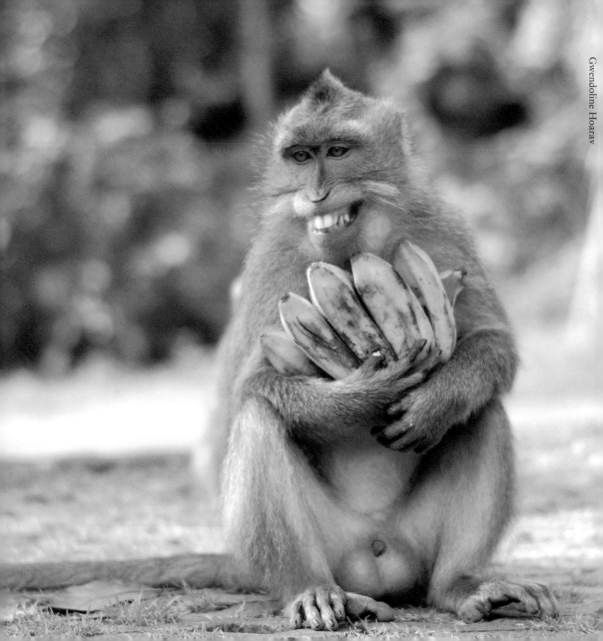

SO IT LOOKS LIKE this Rhesus Macaque got what he wanted for Christmas, (*left*).

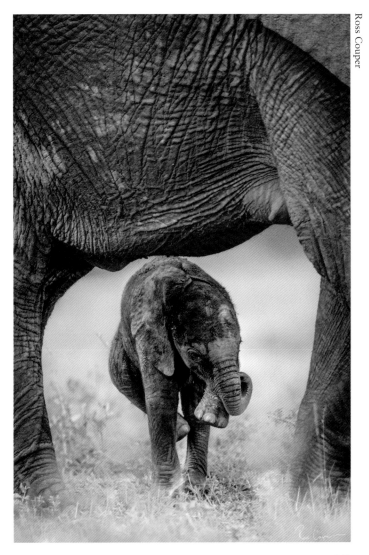

Ross Couper

PLAYING STUCK-IN-THE-MUD is really easy for baby African Elephants. Doing it while leapfrogging is just showboating, to be honest.

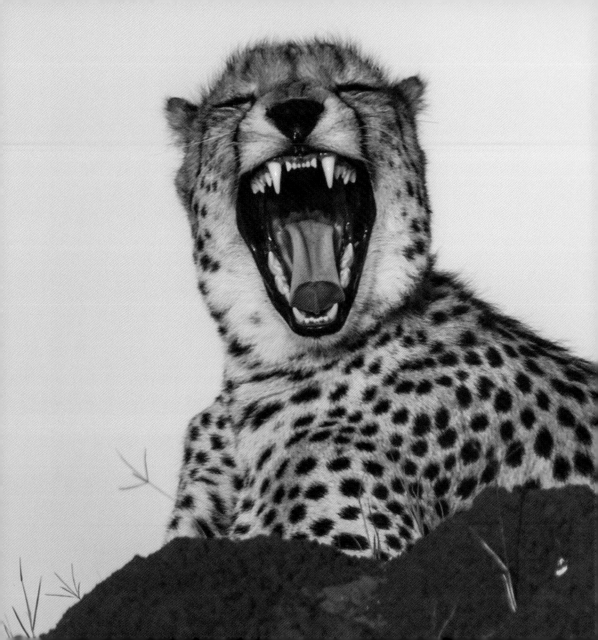

LOOKS LIKE THIS GUY is bored of hearing how he's the fastest land mammal. He's also got 30 teeth, which he's been kind enough to show here.

David Rosensweig

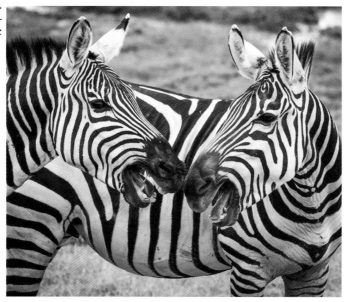

'I DUNNO, what's black and white and red all over?'
'A sunburnt Zebra!'

'I LIKE TO MOVE IT, MOVE IT'. Only found in Madagascar, Ring-tailed Lemurs are sadly now listed by the IUCN as endangered, with only around 2,000 of them left in the wild.

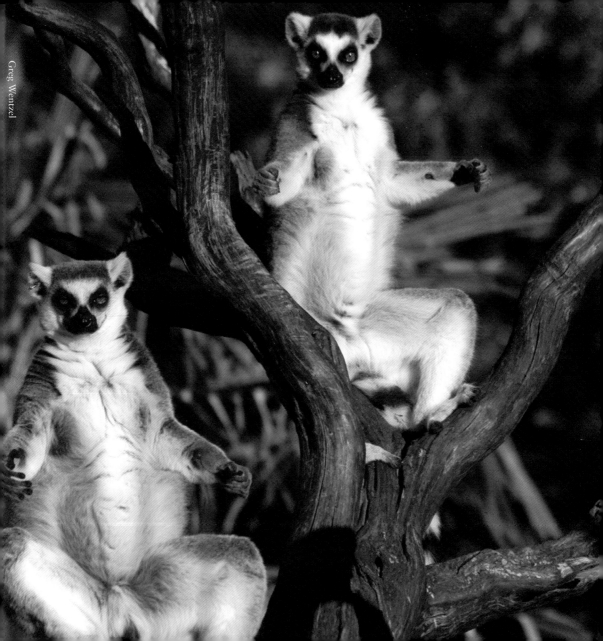

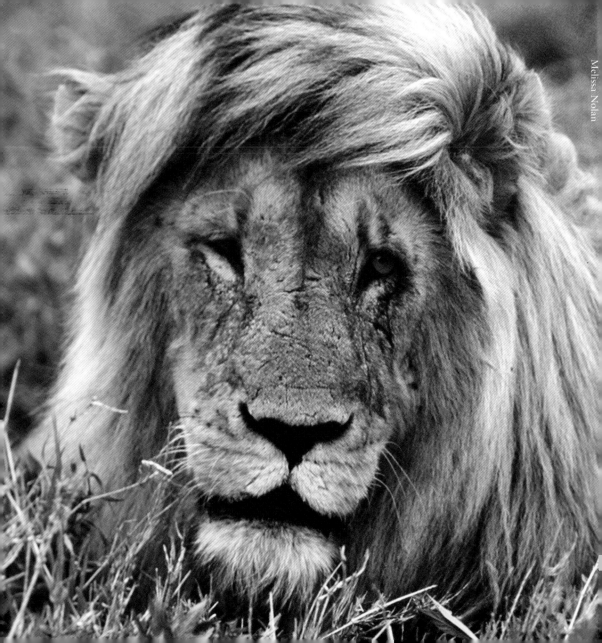

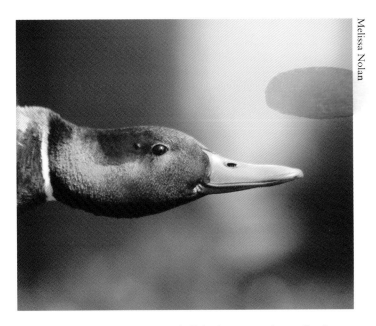

Melissa Nolan

THE MOST WELL-KNOWN of all duck species, the Mallard, is the main ancestor of most domesticated ducks, and makes the distinctive 'quack' noise stereotypically associated with ducks. They're also expert at the limbo.

IT SEEMS THAT trendy side partings are everywhere these days.

THIS PYGMY OWL is making some extra cash during the winter as a Christmas tree topper.

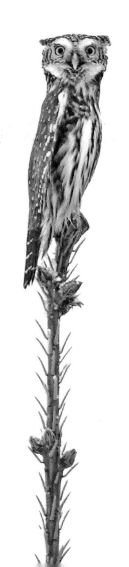

THE BARN OWL, the most widely distributed of all owls, is known by many sinister nicknames, including 'ghost owl', 'demon owl', 'death owl' and 'hobgoblin'. You wouldn't think it, looking at this guy. He's a hoot! (*right*).

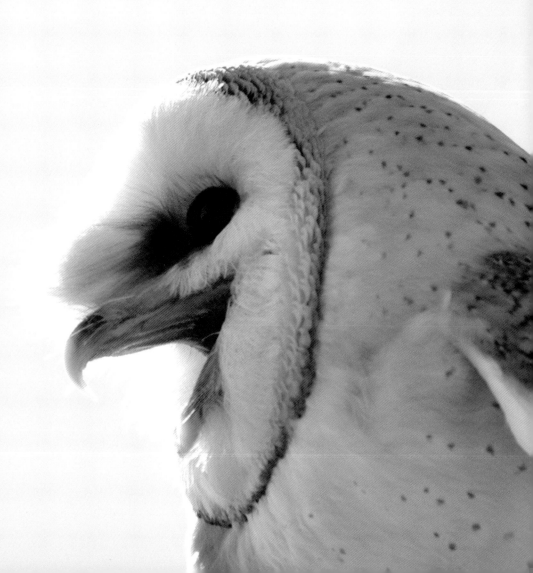

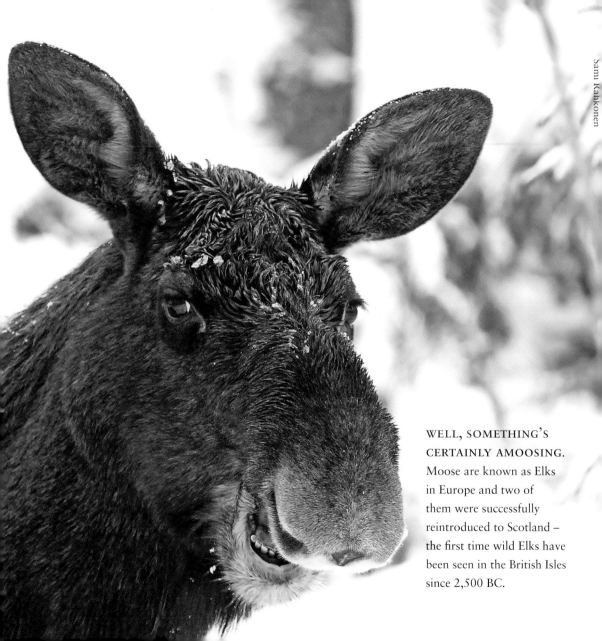

Sami Rahkonen

WELL, SOMETHING'S
CERTAINLY AMOOSING.
Moose are known as Elks
in Europe and two of
them were successfully
reintroduced to Scotland –
the first time wild Elks have
been seen in the British Isles
since 2,500 BC.

TAKE ACTION FOR ANIMALS

RESOURCES

Not all of us get to see wildlife in the wild where they rightfully belong, but you can help animals no matter where you are. Here are a few things you can do to help our planet and its wild inhabitants:

1. Get in touch with your local council. Tell them how you want them to vote on conservation, animal protection, and climate change bills. Representatives listen to their constituents, so make your voice heard. Call, email, or even better, write a letter.

2. Sign up for an email list to stay informed about the issues and learn about proposed legislation that needs your voice. We recommend Born Free at www.bornfree.org.uk.

3. Use social media. Follow and support wildlife conservation organisations to stay up to date on new legislation, current events, and on what is happening in the field. Show your support by becoming an ambassador and sharing their posts with your friends.

4. Donate. Put some of your hard work toward preserving our planet and our wildlife, so future generations will be able to see wildlife in the wild. You want problems solved, and there are experts who are working to solve them, but they can't do it without funding. Also, look further than what you see on TV. Bigger isn't always better; many small organisations are making a huge impact and putting your donations to work for animals. And, remember, no donation is too small. The most important thing is to give something.

We love Born Free. We know them and they use their hard-earned resources extremely well and have made a genuine difference to wildlife across the planet. Both Tom and I have first-hand experience of it.

You can give at www.bornfree.org.uk/donate.

ACKNOWLEDGEMENTS

It would be difficult to know where to start these acknowledgements if Paul and Tom had had much support. Sadly they did this all on their very own, struggling through the multi-disciplined requirements of running a photography competition much like a Cheetah struggles to abide by the recent 40 mph speed limit set on his territory.

Seriously, however, we are joking. We are over the moon that the Comedy Wildlife Photography Awards has taken off with such aplomb since its inception just two years ago. For that success, we would like to thank several people.

Our judges, Kate Humble, Hugh Dennis, Will Travers, Will Burrard-Lucas, Oliver Smith, and Adam Scorey. The Magnificent Six, all individually bringing their own specialism, skill and insight to the judging process, and all elevating the competition to a level it would have struggled to achieve had it been left in our own shaky hands. Thank you, it really has been a pleasure, and we look forward to many more years working with you.

Our sponsors and Partners: Born Free Foundation, Amazing Internet, Kenya Airways, Nomad, Alex Walker Serian, Nikon and last but by no means least One Vision Imaging. The Magnificent Seven this time, and utterly invaluable to the success of this photographic competition. To be able to offer the prizes we do, the exhibition and the website to make it all possible has been a major reason for helping reach so many people and increase awareness of these animals. Thank you to you all for what you have done and what you continue to do.

Our literary agent Natalie Galustian, a fantastic source of knowledge and direction who continues to juggle Paul and Tom's myriad character flaws and help get the show on the road. Which very smoothly leads us onto thanking our publisher, Joel Simons at 535 and Blink Publishing, for performing a very similar role to Natalie's!

And finally, though by no means least, to our families – The Pooch, Tommy & Sammy on one side, and Kate, JoJo and Finn on the other side. They have been so tolerant of our late nights, early mornings, and general disappearance acts (to play golf) and not once have they shown any interest, exasperation with or doubt in our project. For that we owe them a lot more than we can ever pay back. Thank you.

With much love to all of you,
Paul and Tom.

Julie Hunt

ABOUT THE EDITORS

PAUL JOYNSON-HICKS is a wildlife photographer. He lives in Arusha, Tanzania with his Mrs, (aka The Pooch) and his two small boys (aka the Bograts), and his Springers. He loves being in the bush and taking pictures. He was awarded an MBE for charitable work in East Africa over the last 25 years, not for his photography. But we are sure that if he perseveres he might win something one day.

Having spent the first part of his professional life working in financial services in London, **TOM SULLAM** realised the error of his ways to quit everything in order to pursue a career in photography. He won the prestigious Fuji Photographer of the Year award, along with the One Vision prize. He recently moved with his family to Tanzania where the wilds of African landscapes have provided yet another challenge.

IN PARTNERSHIP WITH THE BORN FREE FOUNDATION

The Comedy Wildlife Photography Awards are proud to support the Born Free Foundation, an international wildlife charity founded by Virginia McKenna, Bill Travers, and their eldest son, Will Travers, following Bill and Virginia's starring roles in the classic film *Born Free*. The charity is devoted to wild animal welfare and Compassionate Conservation, working to save animal lives, stop suffering, rescue individuals, and protect threatened species. Born Free Foundation is determined to end captive animal exploitation, phase-out zoos, and keep wildlife in the wild. They take action to protect lions, elephants, gorillas, tigers, wolves, bears, dolphins, turtles, and many other species and work with local communities to find solutions that allow people and wildlife to live together without conflict.

Find out more and get involved at www.bornfree.org.uk.